ISBN 978-0-260-67690-0
PIBN 10055117

This book is a reproduction of an important historical work. Forgotten Books uses
state-of-the-art technology to digitally reconstruct the work, preserving the original format
whilst repairing imperfections present in the aged copy. In rare cases, an imperfection in
the original, such as a blemish or missing page, may be replicated in our edition. We do,
however, repair the vast majority of imperfections successfully; any imperfections that
remain are intentionally left to preserve the state of such historical works.

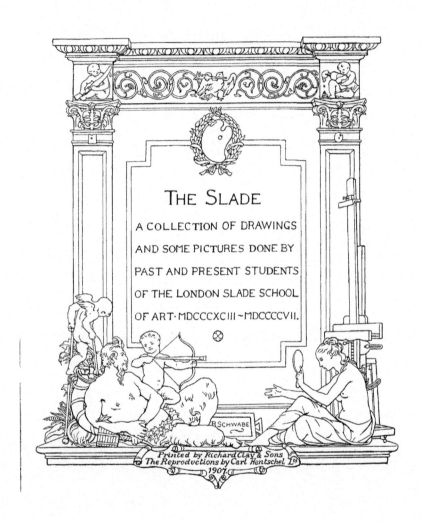

THE SLADE

A COLLECTION OF DRAWINGS
AND SOME PICTURES DONE BY
PAST AND PRESENT STUDENTS
OF THE LONDON SLADE SCHOOL
OF ART· MDCCCXCIII ~ MDCCCCVII.

R SCHWABE

Printed by Richard Clay & Sons
The Reproductions by Carl Hentschel Ltd
1907

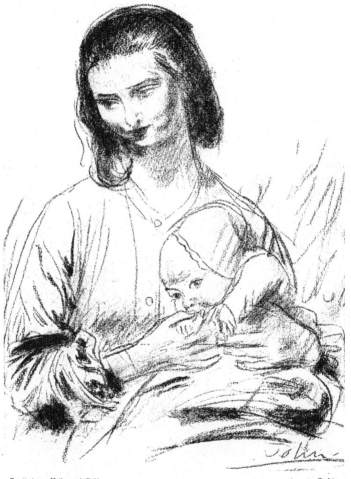

Frontispiece. Mother and Child. Augustus E. John.

CONTENTS

REPRODUCTIONS

THE SLADE

INTRODUCTION

BETWEEN 1896 and 1898 there appeared four numbers of a magazine having some relation to the Slade School, entitled " *The Quarto*, an artistic, literary, and musical quarterly," edited by Mr. J. B. S. Holborn, himself a Slade Student. *The Quarto* is now, I believe, on the booksellers' list of books hard to find. It was suggested last year that another issue should be brought out, and a committee of professors and students was formed for that purpose. But the versatile spirit that originated *The Quarto* was no longer to be found in the Slade School. So it was decided to limit ourselves to producing a number of drawings done by past and present students since Professor F. Brown came into office ; and to a letterpress that should be directly connected with the reproductions, this also to be done by students. After such modifications upon the plan of *The Quarto*, it was thought fit to give the volume a title of its own.

With the expectation of a limited sale, we could not hope to make *The Slade* large enough to be a representative volume. We think we have collected some good drawings, but we know that a great quantity has been missed. It could not have been otherwise, and we regret it. If we have by omission treated unjustly very many, we have also had to give scant space to others who have been reproduced here in only one or two works each. Yet the purpose of the book seemed to us real enough to justify publication, in spite of its limitations and omissions. *The Slade* does not pretend to be an official record. To make it such other volumes would be necessary. These, it is to be hoped, will be undertaken one day, though it is not the intention of the present committee to continue the work.

B

THE SLADE

We are very grateful to the past and present Slade Students who have lent us their works, all of which, with one exception,[1] are here reproduced for the first time. And we beg the indulgence of those whom we have not included. We tender our best thanks to the owners who have kindly lent us drawings to reproduce, amongst whom Mr. Hugh Hammersley, Mr. L. A. Harrison, Mr. Cyril K. Butler, and Mr. F. Inigo Thomas.

We are indebted to Messrs. Richard Clay & Sons for their care and attention in the bringing out of this book. Four of the reproduction blocks were made by Messrs. Ballantyne & Co.; the rest were made and printed by Messrs. C. Hentschel, Ltd.

JOHN FOTHERGILL, *Editor*.

SUMMER, 1907,
 SLADE SCHOOL,
 UNIVERSITY COLLEGE, LONDON.

[1] A portion of Miss Waugh's *Rape of the Sabine Women* was reproduced in *The Quarto*, 1898, vol. 4.

FELIX SLADE AND THE SLADE SCHOOL

AT the Slade School there are few who know anything about its founder, or who have any idea of the real nature of his bequests. Some interest may therefore be found in an account of a man who was one of the first art-collectors of his time, and to whom as Slade students we owe so much.

There is little of biographical interest to tell. Felix Slade was the second son of Robert, a Proctor in Doctors Commons. He was born in 1790, and educated, together with his elder brother, William, to the study of the law. Both brothers, like their father, held the office of Proctor in Doctors Commons, an office which provided a fairly large income, and has since been abolished. On the death of William, Felix inherited his mother's property in Yorkshire, with his father's fortune and a house in Walcot Place, Lambeth. Here Slade lived till his death in 1868, making collections chiefly of books, prints and glass. It is almost impossible to get any idea of Slade's personality, for he died a quarter of a century ago, and few of his friends survive. A pleasant old-fashioned portrait in coloured chalks by Mrs. Carpenter, which is in the Print Room of the British Museum, agrees fairly well with the following description, sent me by one who knew him. "You ask what manner of man he was. Well, I knew him only in his declining years; but he was then a rather striking figure, once certainly above the average height, with a somewhat massive head, a strong but genial aspect, and slightly ruddy complexion. I recollect his pleasant voice and courtly manner; while my remembrance of the hospitality he showed me is always fresh. His great friendship for Franks[1] was evident in all his intercourse with him; and that will be no wonder to anyone who knew the lovable character of Franks, and his extraordinary knowledge of the history and quality of all objects of the kind which attracted Mr. Slade. To Franks is,

[1] Sir Augustus Franks, head of the Glass Department of the British Museum.

I believe, largely due the form taken by Mr. Slade's benefactions for the endowment of the study of the higher arts in England."

Like many collectors of his time, and probably also of the present day, Slade was so seized by the collector's mania that he often did not know when to stop. When the case in his drawing-room was filled with Venetian glass, his shelves with old books and bindings, and his house was quite unable to hold anything more, he was compelled to store his prints at a London dealer's. This may have been partly for the sake of their better preservation. It cannot be good that beautiful things should be hidden away in crowds ; that pictures should be stacked in a cellar, the walls of a room lined with old snuff-boxes, or that a famous antique statue should stand in a spare drawing-room, only occasionally visited by a housemaid. Slade, however, never made a collection in haphazard fashion. He bought always with a view to the beauty of the object, or the completion of some series, a legitimate aim in a collection of antiquarian interest. He was not at all concerned with the mere rarity of his purchase. Thus, his prints are remarkable more for the brilliancy of the impressions than for any unique peculiarities they might possess ; and in his Preface to the Catalogue of the Collection of Glass, he writes : " My aim has been to obtain illustrations of the many curious processes of manufacture and ornamentation to which glass has been subjected."

In 1868 Felix Slade died, leaving the whole of his treasure to the nation. It is unnecessary in this place to catalogue the many collections in the British Museum which received additions from the Slade Bequest. It will be sufficient to say that practically all he had amassed during his life-time—books, prints, and glass, and much besides—were accepted for the national collections on his death. He also left a sum of £3,000 for the purpose of adding to the collection of glass which he bequeathed and which may be identified in the Glass Room of the Museum by a small " s " painted in scarlet at the foot.

The prints are now, of course, distributed throughout the Print Room. The collection aimed at representing each of the various great schools, and included many etchings by Dürer, Wenceslaus, Hollar, Rembrandt, and others. There were also fine series of engravings after the work of Hogarth and Reynolds.

In addition to this magnificent legacy, Slade's will arranged for another equally generous bequest. It directed that a sum not exceeding £35,000 should be expended in the foundation and endowment, within two years, of Professorships for promoting the study of the Fine Arts, one in each of the Universities of

Oxford and Cambridge, and a third at University College, London ; and that a further sum, not exceeding £10,000, should be expended " on the foundation and endowment at the latter place of 6 scholarships of £50 per annum (tenable for 3 years) for proficiency in drawing, painting, and sculpture, for students under 19 : Should any residue be left, the surplus may be laid out by the executors for the encouragement, benefit, and advancement of the Fine Arts in England." To consider the acceptance of this sum a Committee was appointed at University College, Mr. Edwin Field being one of its most active members. The Slade School owes much to Mr. Field. " Our Committee," he wrote, " considered that acceptance of Mr. Slade's bequest would impose on the College the duty of affording such instruction as ought to be given to students who are following the Fine Arts as a profession." The executors were asked to found a " Felix Slade Faculty of Fine Arts," and the College then generously voted £5,000 for building the Slade School as part of the College quadrangle. Sir Edward Poynter was chosen as the first Slade Professor in London. Mr. Ruskin and Sir Matthew Digby Wyatt accepted the chairs at Oxford and at Cambridge, Mr. Ruskin giving a good deal of teaching in the school at the Taylorian Museum in addition to lecturing.

On Oct. 2, 1871, Sir E. Poynter delivered his inaugural lecture at the opening of the Slade School. This happened at a time when Sandys and others of pre-Raphaelite tendencies were anxious for reform in the course of education provided for students at the Royal Academy. Much was hoped for from the new School. The Professor gave reasons in his lecture for presuming that there was room for another school of Fine Arts in England, showing that, except at Burlington House, there was " no school of any importance in London for the study of high art." He made it clear that, though the Slade School " could never be considered to come into competition with that of the Academy," great reform in the course of teaching was possible, and indeed necessary, and these reforms he proceeded to describe. Chief among these was the substitution of a short for a long period of work in the Antique Room before admission to the life class. The system now in use at the Slade School is, without many important modifications, the outcome of this scheme.

It is interesting to read in this lecture (printed in Sir E. Poynter's Lectures, 1878) a vigorous attack on the system at South Kensington, where students were required to produce an elaborately stippled drawing from the antique before admission to the School. He points out how absurd it is to make a student

worry a drawing with chalk and bread for six months or more, learning nothing whatever after the first setting of it out, and becoming quite blind to the original before him.

We may, indeed, be thankful that, at the Slade School, where there is no such entrance examination, this fruitless labour does not form a part of the student's career. Since the time of Sir E. Poynter's Professorship one important branch of the work in the Slade School has been abandoned. In the time of his successor, Prof. Legros, modelling was taught by Mr. Frampton, this being one of the subjects provided for by Slade's bequest. Other changes in routine have been comparatively unimportant.

It is clear that, except in so far as Slade's views were represented after his death by Mr. Franks, the constitution and the creation of the Slade School were not directly determined by him. The creation of it was largely due to Mr. Edwin Field, and it naturally fell to Sir E. Poynter to arrange the course of work in the School.

W. E. ARNOLD-FORSTER.

AUGUSTUS JOHN

SCHOOLS of art there always are (they seem to be most numerous when they produce nothing but pupils), but the art of drawing visits them very irregularly; it fades out and is forgotten, is re-born and dies again. The delicate balance of it is so hard to keep, the point at which seeing, keen and whole, is one act with design, and caligraphy is close moulded upon knowledge. At second-hand the discovery is no longer the same thing; each of the eager disciples who stand round the discoverer has his bias away from the centre, is ready to seize on any point of weakness as a virtue, to stereotype and patent that. We hear a great deal about a " sound tradition," but after the culminations of art there seems to be nothing for it but to break the mould and begin again. What a vulgar artist we should conceive Rembrandt to have been if we had to construct him from his pupils; yet each of them could have pointed to some unlucky moment or tendency in the master that gave him his warrant, to be sedulously magnified. Some of them, to retain the "style," must close their eyes to the object; others, to retain the study, forfeit breadth, and drawing falls away into nerveless bits, disjointed notes of form. The amplitude and ease of Rubens persisted in the drawing of Boucher, but Boucher was the first on record of many artists to declare that " Nature put him out." What could his pupils do in their turn but retaliate upon Nature, unable to bridge the gap between such swaggering caligraphy and the model! The crack came; that particular freedom had grown too free and easy, and drawing, after doing penance in Graeco-Rome, had to be born again in the severer mould of Ingres, once more to be rotted by what in the new master gave an opening to the academies. Rubens, the name of dread in this period, could now prepare his return, purged of his pupils' sins, to descend upon a lady-like generation of draughtsmen like life itself.

First-rate drawing, rare everywhere, has been very rare in England. The sense of beauty has not been rare, but the effect of beauty has often been arrived at by what our fathers called "fudging it out." It is astonishing on

how empty a structure Reynolds based his noble design and rich integument, on how loose a structure Gainsborough wrote his magical expression. Little masters we have had, and one great master ; the full-grown art of drawing was re-born with Alfred Stevens, a drawing in which vision and execution are fused, and expressed by that perfect distribution of the web of traits and accents that carries the impulse of a single being through the structure, keeps it tense and free, and gives proportion not only to the limbs but to the very touches of the chalk.

Stevens, in his earlier years, was a teacher in succession to Dyce at the School of Design. That school became the South Kensington School, and we know what, in other hands, the drawing became that spread through the ramifications of a Government machine for grinding out teachers. Students were encouraged to produce an "outline" of their figures that had little to do with in-lines, a collection of unrelated segments of curves whose reason for appearing where they did was neither indicated nor understood. The true draughtsman does not glue his eye to contours merely where they become explicit in "out-line" ; he thinks of that as only a part of one of the infinite contours of a form, and his work is to relate the bit that has become explicit from its position to lines implied by the inner modelling. Still less does he think of these bits as parts of a flat tracing or projection ; he feels them as the limits of advancing and receding forms. The art student of those days did not proceed thus from within outwards ; having pegged down his "outline" he went on to potter about in the less seizable interior, with painful "shadings." The result was not drawing, but a very tedious and gritty kind of painting with charcoal.

Against such thoughtless labour the Slade School from its foundation has protested. Under Mr. Legros the lesson of determined line and brush work was driven home. There has recently been added to the Tate Gallery, by the gift of Judge Evans, one of that teacher's almost fierce demonstrations for the student of definiteness in stroke as opposed to lazy fudging, the putting down of something that can be judged as right or wrong. The head was painted in an hour and twenty minutes on a public platform before the School of Art in Aberdeen, and is so painted that a single correction must have spoiled, not necessarily the painting, but the particular lesson of committing oneself strongly to a statement of form. It is said that the local art master, trained in the school of stipple and stump, rubbing out and niggling in again, forthwith gave up his post to become a pupil at the Slade.

The School took a second lease of life under Mr. Brown and his colleagues, and the patient intelligence they have put into their work has been rewarded by the production of a new group of draughtsmen, of whom one, Augustus John,[1] provokes my rusty pen. Good pupils in a school come by batches ; contagion and emulation spur the leader on and pull others in his train ; by general consent John was the centre of this second flowering at the Slade. I believe the exhibition in the School by Mr. Brown or Mr. Tonks of reproductions of drawings by Boucher set alight the carefully laid train of study that had been going on, and the practice of setting subjects for composition [2] fanned the flame; anyway there was a sudden outburst of drawings that had verve and style, and a window of imagination opened on the stuffy air of the schoolroom. The hour of Rubens had returned.

The temper of Mr. John is rebellious against the ordinary and scornful of the pretty, and the anarch young has not yet controlled or concentrated his passion to the creation of great pictures ; but he has given us some measure of his powers and indication of their quality. He has made imaginative sketches like his Walpurgisnacht ; he has followed the tramps and the gipsies as so many of the seventeenth century artists were fain to do when high imagination had broken its ancient mould and was departing in curly scrolls of rhetoric ; he has painted portraits first-rate in character, notably one of Professor Mackay, that Highland warrior of the Holy Ghost disguised as a Liverpool don ; he has painted a Mother and Child that everyone detested because it was not a Madonna with an angel child, but a fresh rendering of the ancient theme, defiant motherhood holding up her naughty imp against the world ; he has scattered broadcast drawings with a wild flame of life in them.

I read of him the other day [3] that he had " arrived at once," because " Life and vitality are the fashion at present," while another artist would, for the same reason, have to wait several years for popular recognition. I do not know how this compliment would strike the other artist, but I wish the idea of life going

[1] Entered Slade School 1894. Gained Slade Scholarship 1896. Took Prize for Composition, "The Brazen Serpent," 1898. It may be put on record here that John competed about this time for a British Institution Scholarship, but the judges awarded nothing to so remarkable a draughtsman.

[2] I venture to suggest to the teachers of the Slade School that this useful practice might be developed by adopting Mr. Watts's old suggestion for the public schools ; namely, that the students of the Slade in their last year might be given an opportunity of executing large compositions on the classroom walls during the vacations. Those which did not deserve to be preserved could be obliterated, and the space used again.

[3] *Burlington Magazine* for April, " The Case for Modern Art."

out of fashion were as paradoxical as it sounds. Death, it seems to me, is apt
to be more fashionable in art, and life formidable to its contemporaries ; and if
the art is not dead, it is required that the artist at least should be. I believe
therefore that the writer I quote was really engaged upon a subtle bouncing of
his readers ; he was insinuating an apology for modern art to people who mis-
trust the living ; and Mr. John was too evidently alive to come into the
argument. He is not, I think, very popular ; he has not, I hope, arrived,
but I do hope he is going on, and that prodigal sketching will not be the
last chapter of his story. So lusty an appetite promises growth.

The illustrations of his drawings given here I should describe as a casual
handful, but one or two of them will justify to the unacquainted what some of
us think of their author.

<div align="right">D. S. MacColl.</div>

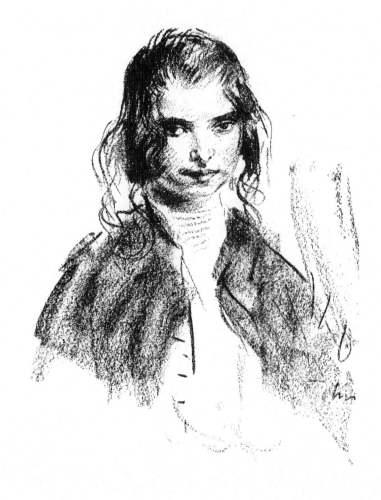

I. *Portrait Head* (sanguine). *Augustus E. John.*

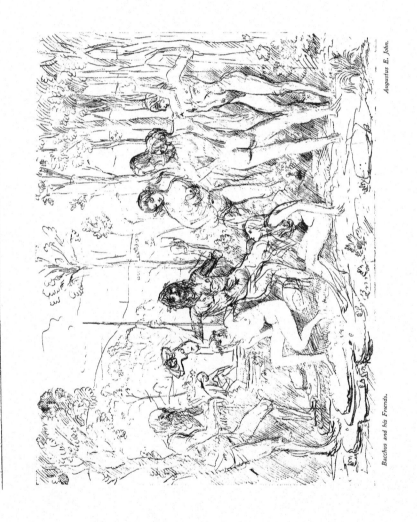

Bacchus and his Friends. *Augustus E. John.*

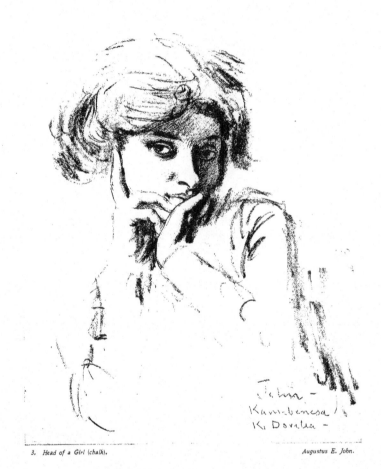

3. Head of a Girl (chalk). *Augustus E. John.*

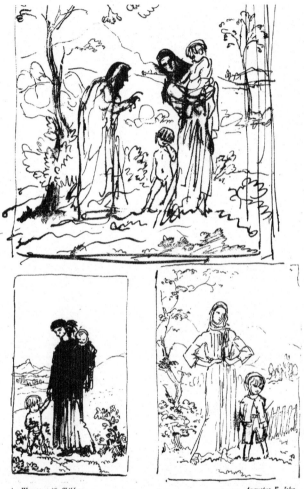

4. *Women with Children.* *Augustus E. John.*

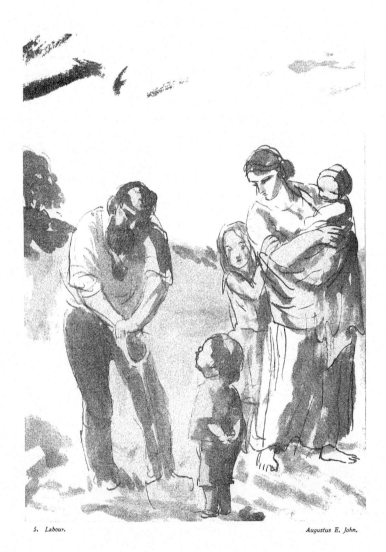

5. Labour. Augustus E. John.

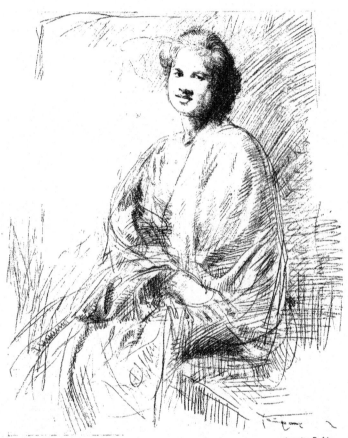

6. *Portrait of a Lady (pencil).* *Augustus E. John.*

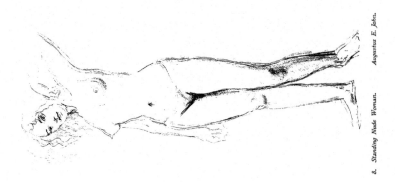

8. Standing Nude Woman. *Augustus E. John.*

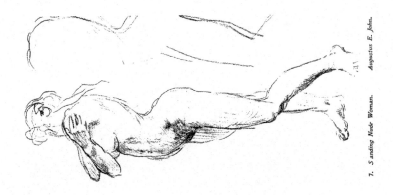

7. Standing Nude Woman. *Augustus E. John.*

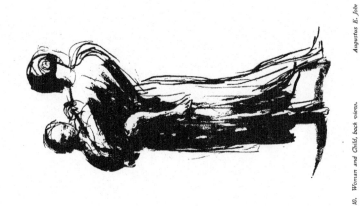

10. *Woman and Child, back view.* Augustus E. Joh

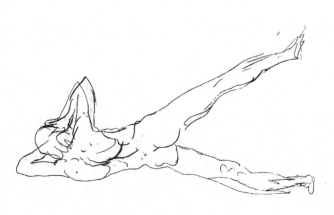

. Nude Man, back view. Augustus E. John.

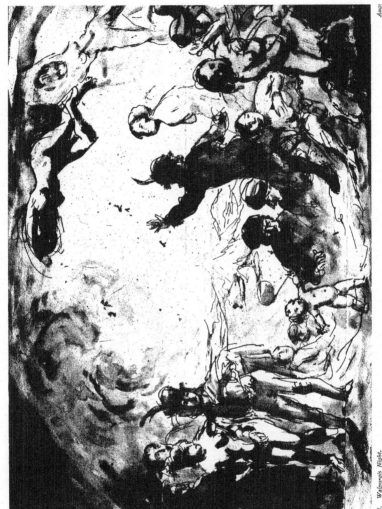

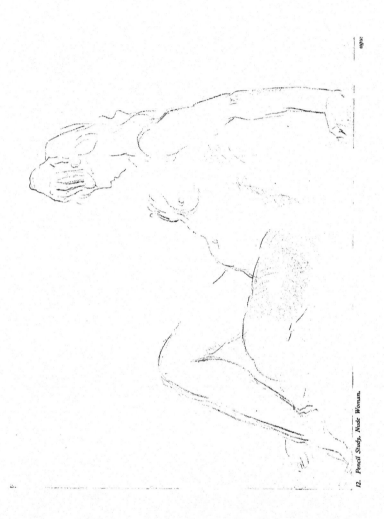

12. Pencil Study, Nude Woman. 1912.

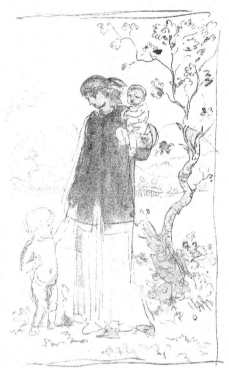

13. *Woman and Two Children.* *Augustus E. John.*

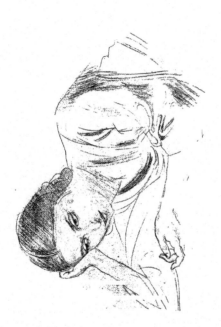

Study in pencil of a Girl.

Augustus E. John.

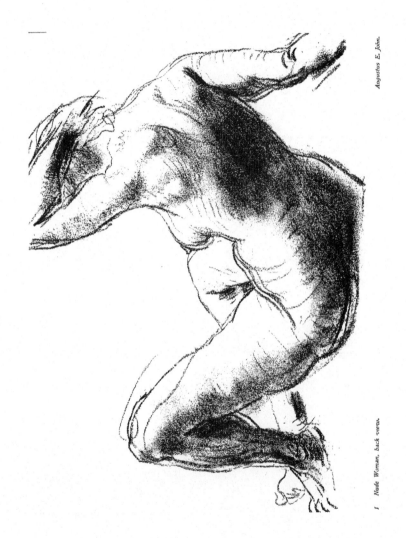

Augustus E. John.

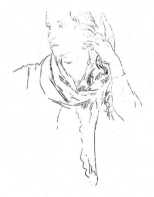

16. *Girl's Head (tracing).* *Augustus E. John.*

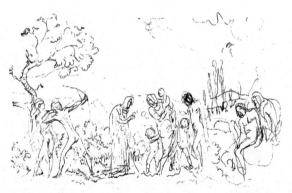

17. *Sketch in Paradise.* *Augustus E. John.*

19. Study of a Baby. Augustus E. John.

Augustus E. John.

The Unicorn.

WILLIAM ORPEN

See also pp. 24-6

Ho ey: playful account, t which various writers contributed, including O. himself

Among the students at the Slade School of Fine Art, at the time of the advent of William Orpen, the general Artistic conceit throughout the School could only be described as stupendous. Clever men swarmed; talent was tolerated, genius condescendingly admitted, but Old Masters alone might share in the company of the Gods. The competitive severity was of the fiercest nature; Pluto had only to do a rather better drawing than Jupiter to give that worthy the cut direct the next day upon the strength of it. Ordinary men were permitted breath. There was more of the workman than the Aeroplanist in Orpen, with his unkempt brown hair growing low over his forehead, concealing almost the two formidable frontal bumps hurled by his Creator with graceful intention above each of the keen deep-set grey eyes and his truly Irish cheek-bones, nose and mouth, the latter feature wide open giving the lie with unconscious humour to the expression of bland national innocence; no collar, but a wisp that had once been green tied around his neck with exquisite care, but utterly useless for purposes of decoration and protection alike. His attire tailed off, so to speak, with trousers matching his coat of such phenomenal bagginess at the knees as to warrant the supposition of a life-long humility. He seemed strangely at home in the big life room, though in no sense was he, when he arrived from Dublin, a brilliantly gifted draughtsman; though he was infinitely above the average of the deities. It was evident to all that he was master of the difficulties of construction and proportion, and that he had a sound knowledge of anatomy, but there I imagine his knowledge stopped. Not until he had been at the Slade for some time could his drawing have been said to have shown that musical balance which betokens the properly modelled plane; a quality that can only come by applying to personal use with due respect the superior knowledge allied to the skilful tutorship of others. His greatest apparent virtue at the outset was his dogged power of mercilessly and unrelentingly finding an intention in

11

things ; he would search for a meaning in the most subtle shadows, pursuing his quarry to its last retreat. Rapid improvement followed as a matter of course, and soon he was painting with the same insistent fury with which he had been drawing, and in the same way gleaning something from each study for the next. His early work in paint was, if I mistake not, somewhat remarkable for a coarseness in colour, but from the first his appreciation of values was evident. And, if he was learning within the School, he was devouring from without, for I found him once at three in the morning hard at work upon a Sketch Club composition, and I have little doubt he was punctually in his place at the School the same morning. These compositions brought to light an original and rare quality. I refer to his power of throwing himself at will into the Artistic personality of Titian, Watteau, Tintoretto, or anybody who took his fancy in something perhaps in the same fashion then as a beggar would usurp the clothing of a rich man. He closed his Slade career with his prize summer composition, when we were given with a startling vividness the results of his labours as a student in London. This work was deemed by many to offend against ethics ; but the Play-Scene in *Hamlet* was the subject given, and Orpen therefore may be pardoned if he brought into this picture an element of poison. Hamlet as a character is a prank within a problem, and Orpen chose a piece within a play. One enters a play-house to view a theatre. Viewing, we find ourselves for once upon a plane of intellectual equity, the world stands revealed in its true nakedness, and the atrocity of a founded inequality lies slain by the thunderbolts of equality. Atmospherically we are charmed ; we are here confronted with a spiritually illuminative humanity, sublimely subconscious of aught that in themselves pertains to diversity. We stare for a story. Well, after all, a plot is but an inexplicable silence. Desiring in the nature of things a world bedecked, we glance heavenwards and the chandelier, rebukes with gentleness. Puzzled, we turn to the play in progress, on the left discerning in a gilded sheen of softness the King and his Queen—the twain are at ease, they belie their profession. We centre ourselves in Hamlet; he leans in shadow with a composure quietly satanic against a corner post of the theatre, but the pillar accepts his presence with a politeness that blends disinterestedly in the mass. Aware, with graduated growth, in front of and to the right of Hamlet, of a dual presence, screened in obscurity, a prolonged gaze shows us a happy couple partaking of the only salute that merits the name of innocence, kissing ; they are lost in themselves, but so too, are the audience and the players ; there is, however, something

supernatural in the gentleman's trousers. To the right and behind him someone in glasses explains, with outstretched palm the play, to a group amongst whom is a lady of lurid charm, beady eyes, and abdominal jewellery, all ignore ; he cares less. There is no concealment here, none eligible members for the home, but they ask, receive, and share their presence without formality. Others there are behind this trio, for the two boxes facing us contain beings ; their outlook is an intense nowhere. The impossibility of being bored arouses curiosity. Who are we ? The egotistical impertinence of self-interest answers in its own absurdity. Turning to the immediate foreground, to the right of the picture, the weighty might of a gaudy shame flings into us a dart pointed, with merciless bluntness. A lady of substance, grossly ignorant of the very meaning of voluptuousness, sits on the outskirts of a bevy of clownish masculines, in postures expressive of a detachment as seemingly logical as an exposition upon the Archæopteryx by a University College professor. She is semi-nude, and toys with her stocking, careless whether she pulls it up or drags it down ; there is nothing even philosophical about her, a mantle of evil would fall from her shoulders as gossamer. Upon her right again, and gazing down upon her, is the figure of a Rabelaisian *danseuse* ; it is impossible to discover in her attitude whether she is or is not, satisfied, with the light that finally streams over her past and into her present, or whether her future, is to be vague and invertebrate. For a student of Orpen's years this was in all ways an amazing performance. The workmanship is so vigorously unhealthy, as to appear to prove, that refined morbidity is the only road to rude health. His own personality domineers, of course, but as a mummer would handle his Punch and Judy puppets, so does he in this precocious effort take upon himself the paint mentality of Goya, Fra Angelico, Beardsley, Rembrandt, Conder, Dicky Doyle, Velasquez, Sidney Cooper, Franz Hals, John, Steer, myself, Murillo, Holman Hunt, Vermeer, Daumier, Gros ; Raphael Mengs, and many others. To those who had been watching his progress, perhaps the most vital portent in this painting was the very marked improvement in the colour scheme, in which the acute observer would detect an undoubted influence from the masters of the Esquimaux Renaissance. One thing is certain ; his labours must have been superhuman, for he read before touching a brush, Smiles' " Self-Help,' " Robinson Crusoe," and the " Pilgrim's Progress." One can only pity the literary Art critic, doomed to view Orpen's *Hamlet*; he would turn away baffled, his agony would be akin to that which a bank-holiday tripper might be

supposed to experience after wearily exploiting the interstices of a forest, and finding himself forestalled at every tree with his initials. Inconceivable to please, inconsiderable to count, the dilettante with an uncontrollable lust for encyclopædia, must even ravish simplicity to establish intricacy for his solution x x x x

Let us suppose that an artist paints a kilt thrown over a chair. This painting, the critic would lament, fails to move me ; it is uninteresting, academic. Exactly ! Enmeshed, by the fire from the cross-pattern, he glances into the brushwork for a bayonet. Orpen at this time had moved into his cavern at the Newcomes Fitzroy Street, from which house he first startled the public world of Art. Calling one day, he received me with an undisguised unwillingness which amply compensated me for my trouble, inasmuch, as I had just breakfasted to his account at the "Yorkshire Grey" cornering the street. Led by my host down a corkscrew stairway, I found myself in a haunt worthy of a Macbethian witch. The only sign of human comfort was a large four-post bed littered with appurtenances of the studio, upon the roof of which sat a monkey stuffed into a pose sympathetically reminiscent of the Nemesis consequent upon some bygone orgy; the only other note of importance being a huge fire-place, starving dismally upon a handful of coke. He waved his hand. "Disorder," I said, "can be your only design." The remark I think pleased him for he threw sullenly enough God knows, some sticks upon the fire and the blaze dispersed momentarily the gloom ; throwing also some bewitching shadows weirdly prophetic of legerdemain to come. I glanced at some canvases against the wall. "But why this raggedness at the corners" I protested ? "I suffer from *Rats*," he murmured. A sad interest held me. "And do you, Orpen," I asked, "when these rebellious intruders upon a state of unnatural calm, these firebrand imps that burn brief mirth, do they, when they seize you, drive you in your despair, to the coward practice of *eating* ? "

.

The Mirror, was the first prominent work Orpen displayed before the public which exhibited at the New English Art Club, again marked the steady advance of his powers, and he was from this time fully recognised as one of the best painters in the country. He also at this time, began turning his attention to portraiture, his work in this direction containing the same powerful properties, which were discernible in his pictures. The next canvas to mark an epoch, was "The Mere Fracture" which exhibited at the same gallery as "The Mirror,"

showed him as having attained an excellence, that would permit of his work being placed in any Company and bearing the ordeal with dignity. Since then, he has persistently advanced and speaking of his work at the present day, I venture to think that *The Mirror*, his portrait of Miss Lumb, recently exhibited in London may be considered, if all his qualities as a whole are taken into account; to be so far, his finest achievement. For one thing, the vivacious little figure who literally skips into the picture, must have been anything but an easy task in herself, but there is no apparent effort in the paint. The bureau and the male statuette upon it are relegated with superb harmony to the figure, and the large circular glass behind fulfils its mission to perfection. The pictures upon the wall are just where they should be and complete the perfect balance of the design. Were it, for the marvellous knowledge and skill displayed in the tone values alone, the picture might rank as a masterpiece ; but the drawing, colour and handling are of the same splendid excellence.

In endeavouring to probe the *material* reasons which underlie to some degree Orpen's success, I think that there can be little doubt that starting work in the Dublin School of Art, whither he was sent at the age of twelve with a rare parental wisdom, he was most fortunate in overcoming many difficulties at an age when the mind is most amenable to the power of receptive depravity. But two marked characteristics stand revealed. His brain and body acting as a combined machine, are in no small degree, responsible for much of his success. The latter unusually strong and muscular, gives him tireless powers of endurance, while the former is remarkable for its intelligible completeness. Where many men would clearly discern the beginning of an end ; Orpen would comprehend the finish, the middle, the commencement. Perhaps nothing tests a man's balance more than an attack upon a theory, which we most of us know even if followed with a happy carefulness may overwhelm us in disaster, because we endeavour to solve the problem proposed. Possessed of abnormal acuteness, Orpen would merely look for possibilities – and – apply – anything – he – found – to – other – – experiments – in – gradually – – evolving – – – from – - different x x x x inferences x x x x the x x x x basis x x x x of, a – x – x comprehensive – – – x x x – – – thoroughness.

As a man, Orpen at the present day is quite unspoiled by fame, and is as modest as he is sensible. But therein lurks danger. What if he became disciple to that fabulous monument of senile self-abnegation, the typical gentleman, playing the grand old game of the time-worn squire, ringing with hands to the

belfry rope, *pæans* to the dictates of his vicar, and collecting butterflies in pugna-cious moments. Or again, M.P. for Dublin, this brilliant artist stands slamming with patriotic fervour the treasury desk at Westminster ; in deference to the clarion asses' bray of popular opinion regarding the shrinking birth-rate of the Ichthyo-sauria, and deploring the hopelessness of the colossal problem, the Empire faces with customary immobility. Let us hope he will waive temptation. He owes some respect to the Slade School, and may I here seize the opportunity of thanking that superb Academy, that institution for the incurably sane, for here it was I first moved in a really intelligent atmosphere. Arriving from a large telegraph office with all its unnameable vulgarities a part of my being, I was at first most deservedly cold-shouldered by one and all. I learnt that civic ambition is only a pretence for internal economy, as viewed by the aspiring intellectualist. I was taught the doctrine of eternal punishment in the glamour of stainless clothes and patent leather boots, and other things of value to a lightsome pauper; and it is my hope one day to give to mankind the Memoirs of my living death, in which work I shall tell of how and why I came to sleep within a certain egg-box. And how, if the intimate history of that structure were known, why, it would survive the Pyramids. And how, true philosophy came to me through cold toes and an empty stomach. And why, my landlord allowed me credit for eighty-six weeks' rent. And how, the madman pretends to know that he thinks he expects payment. And why, in despair I threw myself into the Thames. And how, I found that any fool can swim. And why, procuring a bearskin from Chelsea Barracks, I toured throughout the country as a performing Bruin. And how I was recaptured and made the mascot of the regiment. And why, the battalion was instantaneously disbanded. And how, I slept at Rowton House. And why, writing from thence upon scented and crested paper to the few respectable people I know, they pretended it was funny. And how, I once borrowed sixpence. And why, I killed my antagonist by returning it. And how, I fell in love. And why, I fell out. And how, I fraternised with the denizens of Little Italy. And why, Francini the anarchist took a fancy to me. And how, the worthy man against his choice, now lives in the King's Own Hotel. And why, employed by a firm of foreign jewellers I made plans. And how, I patiently await energy for the burglary, and divers other things. And why I love Bunbury, and how I have never yet climbed a steeple. This monograph, however, is upon William Orpen, and in summing up the " Artistic " principles that make him one of the foremost living painters in Europe, it is for one thing evident that never for one moment

has he forgotten the enormous importance of good drawing; throughout his career he has been constantly improving in this respect. Again, in studying and applying to personal use the work of his mighty predecessors, he has gone primarily for the mind outside the pigment and not the pigment without the mind, and allowing for instance that he has strong affinities with Velasquez and Vermeer, it is in reality a purely abstract compound; he merely visualizes in the same spirit, for the foundations of his own superb art are his own inclinations. The future of this inimitable painter may be safely left in his own hands. Standing upon the plane of dignity that he now does in his profession, there would seem to be little doubt that given health and strength, in twenty years' time he will be admitted the great Spaniard's equal, or at any rate worthy to stand upon a pedestal beside him; that is, if he doesn't find his Scylla in the platinum wiles of the rising moon, and his Charybdis in the red dread blood-lust of the setting sun.

STEPHEN GRANGER.

DRAWINGS

WILLIAM ORPEN

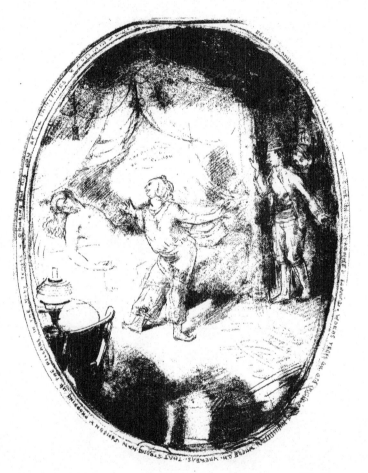

20. *Samson and Delilah.* *William Orpen.*

21. *The Happy Hypocrite.*

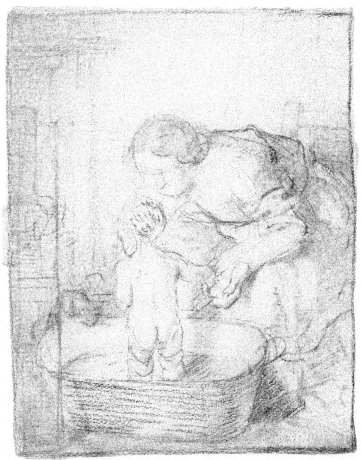

22. The Bath. *William Orpen.*

Gir by a Window. William Orpen.

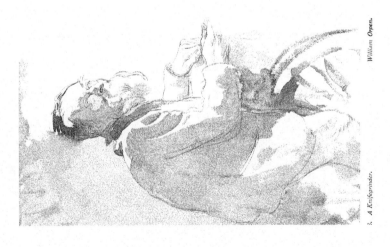

. A Knifegrinder. William Orpen.

25. *Study for the Maypole.*　　　　　　　　William Orpen.

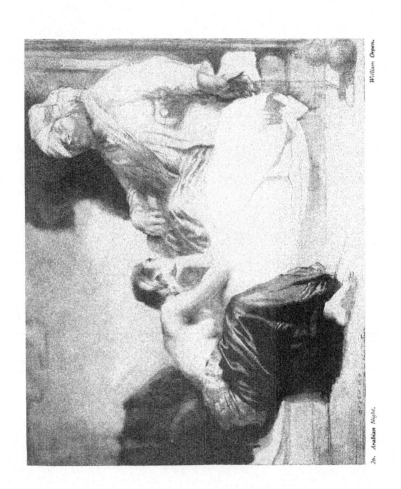

26. *Arabian Night.* *William Orpen.*

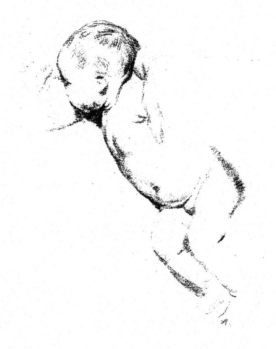

27. A Baby. William Orpen.

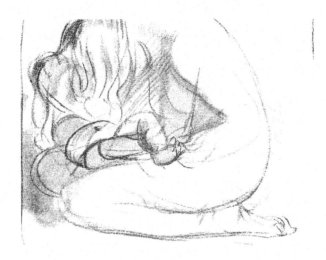

28. *Nude Woman and Child.* *William Orpen.*

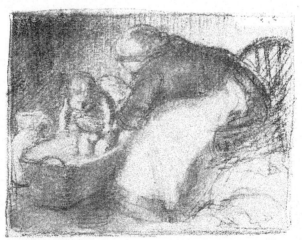

29. *Woman Bathing a Child.* *William Orpen.*

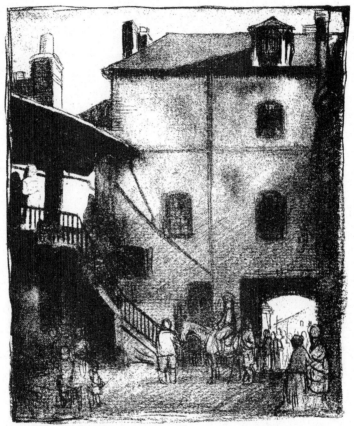

30. *A Court Yard.* *William Orpen.*

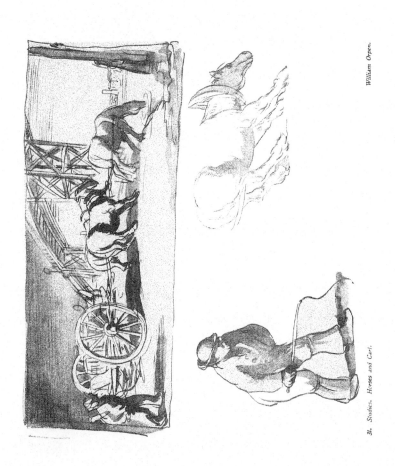

31. Studies. Horses and Cart.

William Orpen.

EDNA CLARKE HALL

GENIUS for life, and genius for art, these are great gifts : in the work of Edna Clarke Hall both are apparent. The smallest fragment amongst her drawings is intimate with nature, and they are all bent upon its expression. The things of life that have come into her personal experience are her subjects. Even those drawings of hers which illustrate scenes from books show that the incidents depicted have been realised by the imagination in a way that may be regarded as identical with experience. So ingenuously is the moment's happening told in these illustrations, that they are full of more than momentary interest. They suggest the character of the story and convince us of its actuality. The author is thereby dramatically assisted by the illustrator. In all her work imagination and realism are more than brought together ; they are so united that they lose their separate identities. Her subjects, whether actual or imagined, are treated realistically, but the realism itself is always imaginative. In the most laboured and in the most unstudied drawings there is always this refreshing characteristic. Accuracy in her hands retains the charm of spontaneity, whilst the most erratic studies show an understanding of the truth too broad to require what is understood by accuracy. When infinite care has been bestowed the " point where sense and dulness meet " is not to be found, as it is so often in the average piece of conscientious work, and in her waywardest sketch there is no hint of an attempt to draw for " style." In whatever way expression has been found, the meaning has been the ruling motive, and to this habit of working, consciously or unconsciously, for meaning alone, is to be attributed that quality in Edna Clarke Hall's drawings which gives them a place amongst genuine works of draughtsmanship.

In a study of a figure by her, not only is the construction true to the attitude, but the capability of movement is forcibly implied ; there has been no working from life as though it were a " nature morte " subject, set to try technical powers. Technical qualities she has of a fine kind, and though they were acquired by the close and constant labours of studentship in early days, they have

no trace of any source but the moment's desire for expression. Whatever patience or impatience her works may have cost her in the making, they are as natural and unaffected as the interiors of barns and the romantic open-air scenes they represent. The difference between this kind of work and that of the academic order is as that between a hand-made and a manufactured vase. Her very departure from mathematical certainty in many instances suggests a truth and beauty that a coldly matter-of-fact work would miss. In some of her studies her power of selection has been used almost wantonly, and by this she shows her ability to endow the most prosaic objects with a peculiar attractiveness. She makes her selections, however, intuitively, and not in a spirit of critical preference. Whether drawn directly from Nature, from original sketches, or from impressions retained in the memory, her work is characterised by a convincing charm and vigour which will be evident to the uninitiated as well as to those who understand the technicalities of draughtsmanship.

Some interest may be felt in the early years of Edna Clarke Hall, then Edna Waugh. When a young child she showed an inclination for artistic expression, and at the age of fourteen she became a student at the Slade School. In those days her sketch books were filled with subjects such as naked children in meadows, wistful Pandoras, and angels, all more or less crudely coloured, but with much primitive charm in them. Her latent abilities were soon recognised and encouraged, and by degrees the character of her work changed. One stage after another was passed through, and work was constantly enjoyed. In *The Rape of the Sabine Women* (Pl. 50 of this book), still hanging in the Slade School, is to be found one of the last productions of her studentship, which extended over five years, towards the close of which she obtained a scholarship ; circumstances, however, led her to renounce it soon after it was won. Since then her work has continued at its own pace, and sketches have accumulated more or less unobserved. Though essentially an artist, drawing and painting have taken their place with such occupations as digging and planting without apparent preference, and it is clear that her art has not lost by its rougher companionship.

ROSA WAUGH.

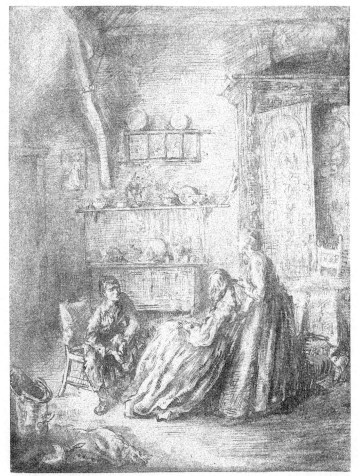

32. *Wuthering Heights.* *Edna Clarke Hall.*

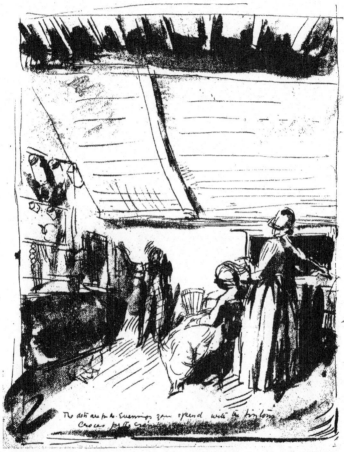

The dots are for the evenings you spend with us so long Crosses for the evenings

33 *Study for Wuthering Heights. Chap. VIII.* *Edna Clarke Hall.*

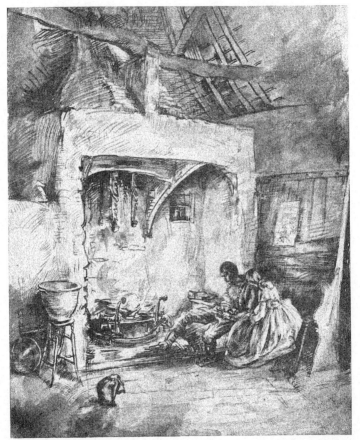

34. *Hareton and his Cousin.* *Edna Clarke Hall.*

35. *A Street in Chelsea.* *Edna Clarke Hall.*

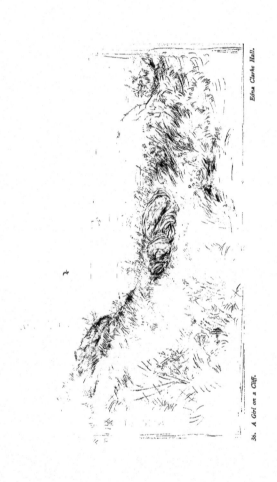

36. A Girl on a Cliff.

Edna Clarke Hall.

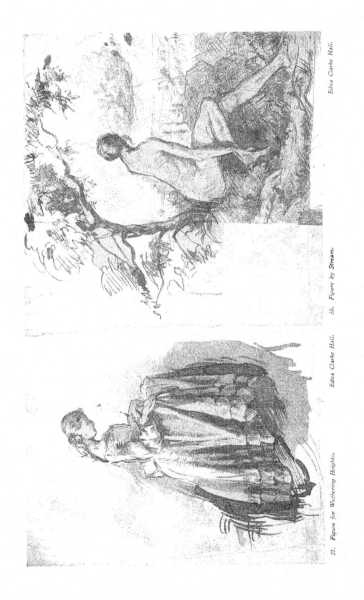

37. *Figure for Wuthering Heights.* *Edna Clarke Hall.* 38. *Figure by* **Stream.** *Edna Clarke Hall.*

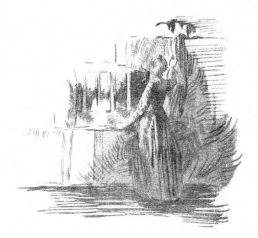

39. *A Girl drawing a Curtain.*　　　　　　　*Edna Clarke Hall.*

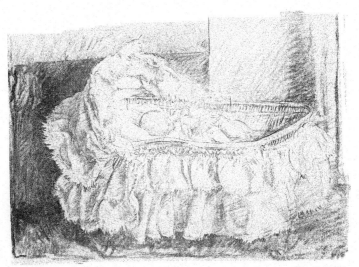

40. *A Baby in a Bassinette.*　　　　　　　*Edna Clarke Hall.*

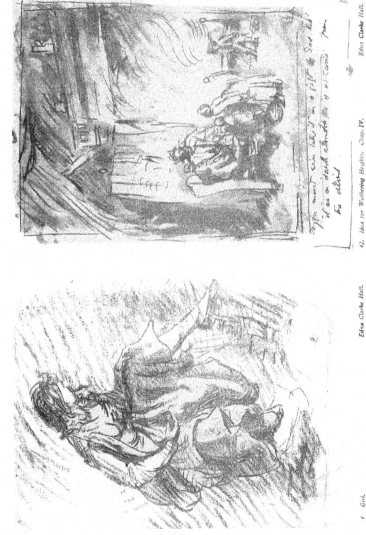

Edna Clarke Hall.

42. Idea for *Wuthering Heights. Chap. IV.*

Edna Clarke Hall.

† *Girl.*

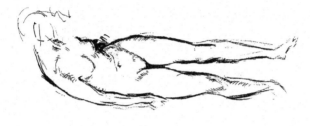

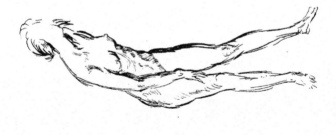

Edna Clarke Hal

44.

43. Slig t Nude Studies.

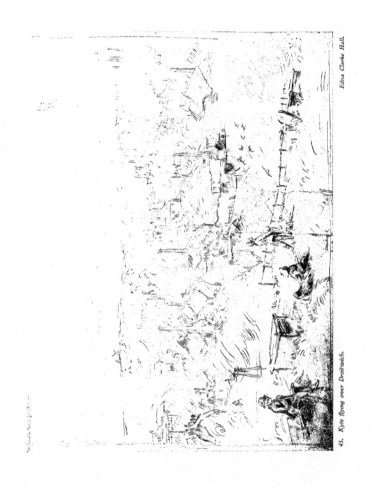

45. Kyte flying over Droitwich.

Edna Clarke Hall.

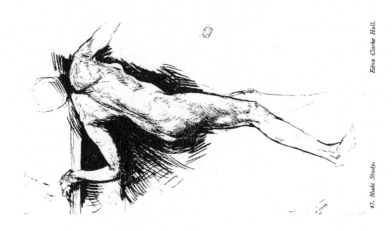

47. Nude Study.

Edna Clarke Hall.

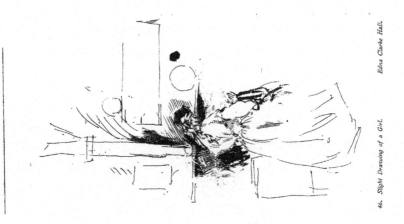

46. Slight Drawing of a Girl.

Edna Clarke Hall.

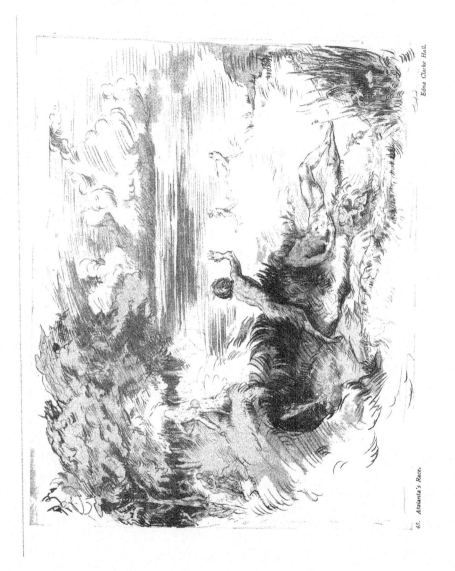

43. *Atalanta's Race.*

Edna Clarke Hall.

THE SLADE SCHOOL SUMMER COMPOSITIONS
SINCE 1893

THE painting of a figure composition based on a given subject is the final test of accomplishment in nearly every school of art. His achievement in this direction marks the end of the first stage in the painter's education, the stage of pure studentship. In such a work a student may display all that he has learnt in the school, and elsewhere, of drawing and painting from life, of the setting of figures in space, of the design and construction of a picture. In addition to this he is afforded scope for original and imaginative creation.

Refreshing, however, as are originality and imagination, and essential as they must be later, they cannot form the sole basis upon which to judge a student's picture. We must take into account the impossibility of selecting a subject that will fire the pictorial imagination of all competitors alike. We may also reflect that the most brilliant or profound ideas may be spoilt in the carrying out through lack of experience, and that the student's experience in this direction has hitherto been of the nature of sketches and projects rather than that of a realisation so complete and on so large a scale as he is now attempting. We may admit, therefore, that those more material qualities which it is the express aim of a school of art to teach must always weigh heavily in judging a school competition.

The standpoint of the Slade School is non-academic and individual, but its training is no less thorough and searching than the traditional and academic. Its teaching both in the life class and in the composition classes of the " Sketch Club " aims primarily at a highly trained, direct vision of nature, supported by a study of the methods of rendering nature employed by former painters. Its attitude towards the Old Masters is not one of ceremonious and conventional admiration; it

21

suggests no attempt to bandage the eyes of the student and blind him to what is not to be found in their works. It is rather a love of, and familiarity with, the old work, a habit of living easily with it and constantly referring to it for help in difficulties. Such an attitude produces a stimulating sense of nearness rather than an overwhelming one of distance.

Holbein and Michel Angelo, Rubens and Rembrandt, Ingres and Watteau, certainly a catholic choice, are freely studied as expressing in different ways one and the same subject—Nature.

In composition, fundamental principles such as balance and arrangement of masses are constantly considered, but the use of fixed systems of rules and receipts deduced from the works of others is not encouraged. Importance is attached to the expression of substance and relief in figures and setting, and a decoratively pleasing composition of line is not allowed to justify unnatural movement and lack of construction.

The competitions since 1893 show, I think, a number of paintings interesting both in themselves and as promises for the future. At the same time they afford a fairly close register of the ideas moving in the Slade School during this period.

Before examining the results of the competitions in detail, it may be interesting to trace some general tendencies in the series. Earlier than 1897 the work was not of remarkable interest, and has not been preserved in the School. In that year Mr. Maxwell Balfour's painting (Pl. 48) gives evidence of a movement of great vitality towards seriously tackling the difficulties involved in carrying out a picture of considerable size and ambition. This movement reaches its highest point both in energy and technical skill in the work of Mr. John (Pl. 50) and Mr. Orpen (Pl. 52). In Mr. Orpen's *Hamlet* the naturalistic impulse is noticeable which forms the key to the development of the competitions for several years. A feeling of the necessity for an artist to paint the life of his own time rather than what is known vaguely as " high " or " ideal " art led to a broadening of subject to such open ones as *Bathers, The Musicians, Workers* ; while in 1901 the subject was left entirely to the student. The tide of naturalism continues more or less strongly down to Mr. Oakley's *Workers* in 1904 (Pl. 56). But in 1905 a distinct change of direction is shown towards a manner of conception that does not illustrate everyday life, a direction towards a more decorative effect than had been yielded lately by naturalism. The work of last year confirms this. The question of colour naturally moves parallel with these ideas. Starting from the decorative

scheme of Mr. Balfour's *Rape of the Sabine Women*, the colour problem becomes more and more merged in that of tone and realistic lighting, while in the last two years the consideration of colour for its own sake is more noticeable than in any work since his. I should like to mention here the constant effort of the professors to meet the changes of idea animating the students by varying the scope of subject and other regulations.

The prize-works reproduced with this article will illustrate the tendencies traced above, except that the important quality of colour is absent. Its absence is felt most by the best pictures and suggests a more uniform degree of merit than is actually the case.

Turning to the competitions in detail, we find two paintings of great interest produced in 1897 by the subject *The Rape of the Sabine Women*. The first prize was won by Mr. Maxwell Balfour with an extremely thoughtful and thorough working out of the theme (Pl. 48). The treatment, composition, and scheme of colour are largely based on the Old Masters, the influence of Rubens and Vandyke predominating. The picture is at the same time full of strong and natural move-ment: studied composition of line has not been allowed to dictate poses which are not the outcome of the dramatic situation. As an instance of this, notice how the kneeling woman in the foreground is connected with the left-hand group by figures in poses equally the outcome of their personal share in the struggle and of the necessities of composition. The two children on the extreme right, unfortunately scarcely visible in the reproduction, form a charming episode owing nothing to the Old Masters. The colour is chosen from a decorative point of view, strong blues and reds on a basis of warm brownish tones, and is cleverly disposed to clear up the composition and make it easy to "read off." It is interesting to note the influence of the Flemish School in the thin, fluent paint-ing, more heavily loaded in the light parts, almost the only instance in the series where the practice of the Old Masters has markedly influenced the actual handling of paint.

The second prize in this year fell to Miss Edna Waugh (Pl. 50). Her water-colour composition has a freshness of conception, with a freedom and enjoyment in the carrying out, both delightful and unusual in a competition on a set subject. The composition is not so complete, not so logically subordinated to a general scheme, as Mr. Balfour's, but the groups are all full of " go " and of great variety. The struggling figures on the cliff, with the natural wriggle of the woman, and the finely designed double group of horses, are a few of many interesting

episodes. One notices, too, the attempt to express individual emotion in the various heads.

The year 1898 produced Mr. A. E. John's *Moses and the Brazen Serpent* (Pl. 5*b*). If Mr. Balfour's is the most decorative painting in these competitions, this, surely, is the most dramatic. The subject is frankly accepted and treated with tremendous energy both in design and execution. Composition even in the academic sense, of line, mass, and colour, is here, large numbers of figures are grouped with apparent ease, but there is a feeling of natural, unconscious growth, of almost organic life, in the constituent parts, which sets it apart from " composition " considered as mere space-filling. Groups in different planes are skilfully linked together—the finely invented figure of the boy with uplifted arms is a good example connecting the central figure with the groups of the middle-distance. The action is well sustained—note how the furor of movement extends to the trees and sky—groups and single figures of great interest abound, but the attention is firmly concentrated on the central figure of Moses and the effect of the whole design is very impressive. Frank borrowing from older work and frank portraiture go side by side. Rubens is again the master nearest in affinity on the creative and dramatic side. The colour, too, is related to Rubens, in its warm general tones with contrasting reds and greenish blues well echoed through the picture, but is more fused by the action of light. Altogether the knowledge, robustness, and solidity of this and the prize-work of the following year mark them as the finest achievements in the competitions and the most characteristic of Slade influences of the period.

A very able charcoal cartoon by Mr. Chas. Stabb took the second prize (Pl. 5*c*). Vigorous, if rather rhetorical, it contains many passages of fine gesture and excellent drawing. The influence of the Old Masters is again strongly shown, in parts, that of Raphael, perhaps, a rare one in these paintings. Some confusion in the arms and legs of the central groups suggests the important part that colour may play in explaining an elaborate design.

In 1899 the acceptance without protest of the " historical " or " classical " subject usual in such competitions breaks down. Mr. William Orpen, instead of giving a version of Shakespeare's Hamlet (the subject announced), deliber-ately and very ingeniously dodged the impending " historical " picture by

painting the interior of a theatre with a rehearsal of "Hamlet" in progress. Having in this way entirely changed the scope of the subject, he gave free rein to fantasy in costume, character, and incident. Hamlet himself, posed in shadow against the brilliant stage, watching intensely the effect of his plot, has a dramatic suggestion, but many of the figures seem cheerfully unrelated even to a fancy-dress rehearsal audience. There remained the painter's problem of composing into a picture these fantastic elements and realising them in paint. This is done with a thoroughness, technical ability, and ease surely very unusual in a student.

The composition is primarily one of tone rather than line, and the system of light and shade is scrupulously and logically worked out. For the theatre and its lighting a long series of studies were made at the fascinating Old Sadler's Wells Theatre, Islington, well known to students of the period. The sense of unity and envelopment are excellent; the colour, being thoroughly related to the scheme of chiaroscuro, is very harmonious, though containing strong passages of red and gold in the curtains, and yellow and blue in the dresses. A dark setting of heavily curtained pillars and stage paraphernalia is used to frame and focus the artificially lit stage and theatre. A charming and most painter-like detail, though perhaps the most wilfully unrelated to the subject, is the semi-nude figure in the right-hand corner. The contrast in colour of blue stocking and flesh in daylight is very fresh and delicate, and the modelling, especially in the head, is developed from its surroundings in a most sensitive manner. The leading influence this time comes not from Rubens, but from Rembrandt. 1899 was the year of the Rembrandt exhibitions at the Royal Academy and the Print Room of the British Museum, both arousing keen interest and study in the School. The scene on the stage is practically a *pastiche* from Rembrandt, and many other influences, such as Watteau and Goya, might be traced, but they lie more in the choice of characters and costumes than in the seeing or painting. It is noteworthy that not the smallest and most insignificant figure is shirked or scamped in drawing.

The whole painting has a lurking air of irony and bravado which comes as rather a shock in a sober competition, but is distinctly amusing in its traces of inner Slade History—there is a fair physiognomical record of the School of the period in this painting and Mr. John's *Moses*. Altogether Mr. Orpen's

E

Hamlet is pure *tour-de-force*, but it serves to display a thoroughness of training at all points which gives a very high standard of studentship.

In 1900 the subject of *Bathers* was sufficiently open to include all varieties of treatment. The result was a practically universal discarding of the " historical " for the " actual " point of view. The first prize was divided between Mr. C. J. Tharp and Mr. Max West. In Mr. Tharp's painting (Pl. 52) landscape interest took a prominent part, a river winding through flat, well-wooded country. Parties of girls are bathing or sitting on the banks in the foreground. The figures are gracefully arranged and drawn, especially a nude child in the fore-ground; and every part of the picture has been carefully studied. The colour is pleasant and rich, though perhaps over-refined. One of the best points of the painting is the rendering of the sunlit landscape.

In contrast to this, Mr. West's picture is carried out in greys and browns. The treatment of the theme is somewhat fantastic : a queer choice of character in the figures, and their lack of mutual interest, with rather loose construction, gives a look of incoherence to the whole, but the conception is carried out on a large scale and with great determination ; and, notwithstanding its faults of perspective, the picture has parts of high merit. The painting of sky and pool has " quality," and a strong feeling for light and space is shown in both sky and distance.

There was no set subject in 1901, choice being left with the student. The first prize was gained by Mr. Albert Rothenstein with a painting of a modern interior—a London interior of a type very familiar to art students (Pl. 53). There is evidently some " story " influencing the action of the figures (it is based, I believe, on a scene in Zola's novel *La Confession de Claude*), but it has served only as a motive to the painter, and is not explicit in the picture. This is very carefully studied and painted, with no attempt at dodging the difficult passages by clever or *chic* painting. The figures are certainly portraits, the old lady seated on the bed being very wittily characterised. The bright red wrap on the kneeling girl (the weakest part in the painting) and the blue of the bed-spread are the only notes of strong colour. The rest of the painting is practically in monochrome, but tones are so accurately observed that this is the most satisfying portion of the painting. The characteristic outlook from the window is cleverly rendered, and the handling throughout is very painter-like and mature.

A subject was again set in 1902, though a very open one, *The Musicians* (Pl. 54). The first prize was won by Miss M. A. Wilson. Musicians in a barn and dancers in the open are the main themes in what may be called an idyllic treatment of the subject. The whole is carefully and capably worked out, though the sentiment of the composition differs in character from most of the series. The nearest " boy and girl " group somewhat takes attention from the musicians, but there is pretty movement in the figure of the girl. The barn with its elaborate structure fits admirably in the composition, and is drawn with keen interest.

Up to this year there had been no limit as to the size of .competition canvases. At the ambitious period of *Hamlet* and *Moses* these grew to large proportions, though handled without apparent effort. It was afterwards felt that the effort to keep up these heroic dimensions was becoming a strain on many students, and unnecessarily with the more realistic treatment then so much favoured. So in 1901 a limit was fixed of 4 feet by 3 feet. This held good until 1906, when in deference to a feeling that more space might be required for such a subject as *Mammon*, the rule was altered to " not less than " 4 feet by 3 feet.

In 1903 the Prize was taken by Miss B. P. Whately. The subject of *The Good Samaritan* (Pl. 55) produced little of strong dramatic interest. The prize-work is a good instance of the aim of most of the paintings sent in— a working out of the scene chosen in a natural scheme of light and shade with reference to actual life for details. The two figures and the donkey are carefully studied from models, and so is the setting of sheds and farm-yard in strong sunlight.

The naturalistic tendencies reached their frankest expression in 1904. The subject *Workers* sanctioned this, though at the same time giving scope for dramatic or emotional treatment. Mr. H. K. Oakley's prize-work (Pl. 56) is a simple and rather literal rendering of a hop-barn interior, with three figures at work in it. Though the attention is somewhat divided, the action of each figure is excellently observed and rendered, and the barn well painted.

The competition of 1905 is interesting as giving a complete change from the realistic point of view. The subject, *Suffer little children to come unto Me*, may have had its influence in this direction, or it may be taken as evidence

of a new tendency already in the air. The first prize was divided equally between Mr. W. I. Strang and Mr. R. Schwabe. Both these students took a view of the subject that might be called "conventional"; both aim chiefly at a decorative result, and owe largely to the Old Masters.

Mr. Strang's painting (Pl. 57) shows a pleasant and carefully thought out scheme of colour, and seems complete in its achievement of what it set out to do. The landscape on the right, and two of the women standing against it, show more first-hand observation of nature than the rest. The central figure perhaps hardly realises the interest expected in it.

Mr. Schwabe's work (Pl. 58) is carried out with great thoroughness and ability. It is the most academic of the paintings under notice, and in this case one feels that naturalness has been to some extent sacrificed to composition of line, which is, moreover, a little obvious. Nevertheless, it contains plenty of very good drawing of action and movement.

It is curious that, contrary to the rest of the series, in both the works of this year the figures are practically all in one plane, parallel to the plane of the picture.

In 1906 the new tendency is confirmed. With *Mammon* as subject many ambitious paintings were sent in, and the "every day" treatment seemed to have practically disappeared. The paintings sent by Miss E. Proby Adams and Mr. Edward Morris divided the first prize.

In Miss Adams's cleverly handled work colour for its own sake has a prominent share in the conception. Unfortunately, it loses in reproduction by virtue of its excellence and daring in this respect. The brilliant blue dress of the girl offering to Mammon tells powerfully on a pleasant and well-balanced warmer scheme, though it seems a little too detached and uninfluenced by reflection and cast shadows. Well composed, the figures—of considerable size—are solidly constructed, and show very keen and interested observation. Notice may be taken of the cast-away flowers, very fresh and charming in colour, and painted in a perfectly simple, unforced way. Though scarcely satisfying in unity and envelopment, the whole painting is full of vitality.

Mr. Morris's picture (Pl. 60) is unique in this series in its thoroughly symbolical conception. The influence of Mr. Watts—certain to intrude on the student of to-day approaching this class of subject—is easily noticeable, but the underlying idea is fresh and clear and is not made an excuse for slackness in technical

expression. The colour scheme has considerable beauty and distinction, and the retreating planes are cleverly suggested in the transition from the rich warm colour at the bottom to the cool simple tones of the sky. The figure of Nature is sensitively placed and ample in design, and the drawing throughout is good. The figure of Mammon is particularly noticeable in its sculpturesque, all-round knowledge of form. The symbolical and decorative treatment has not to deal with the difficulty of a logical natural system of light and shade, with its constant restraint on the spinning of the composition, but Mr. Wilson Steer's comment, "There are no holes in it," is high praise, and well merited. The loss in reproduction is again very apparent.

It is pleasant to be able to conclude a review of the paintings since 1893 with two works of such promise. Moreover, the average of the competition of 1906 was unusually high, showing more animation than has been seen for some years. It is evident that the School has once more a group ·of clever students working with interest and vitality.

To study a series of prize-works like this, showing so much talent and energy in successive students, inevitably suggests reflections as to the outcome of it all, such questions as what becomes of the gold-medallists, the winners of competitions, and where are the Prix-de-Rome of yester-year ? Certainly it would be interesting, perhaps rather disquieting, to have definite information as to the after successes in art of the prize-winners in the great painting schools. So much goes to the production of pictures that eventually count ; not great talent and careful training alone, but in addition so much character, so much experience and favourable circumstance. Then some artists develop late and others prematurely; altogether, prophecy in painting is at least as uncertain as in other things. Everyone knows that many of the finest painters have not gained high awards in their student days : the names of Millet, Rousseau, Manet, Puvis de Chavannes, Rossetti, and Whistler suggest themselves at once. Yet each generation regards as ridiculous the short-sightedness of its predecessors and is assured of its own infallibility, and I suppose every school hopes to arrange its tests in such a way as really to distinguish the most genuine ability. The painters whose work falls under the scope of this article are as yet too near in time, too young in production, to offer a standard of comparison. Still, we may point to the rapid successes of Mr. John and Mr. Orpen, which are already widely recognised as both brilliant and solid. The delightful drawings of Mrs. Clarke Hall (who as Miss Edna

Waugh was a prize-winner in 1897) are dealt with in another article. Besides
some portraits, Mr. Maxwell Balfour has done figure paintings on a large scale
for decorative purposes, interesting for their virility and avoidance of the affectation
so often associated with " decorative " work ; Mr. Albert Rothenstein is a member
of the New English Art Club, and Mr. Stabb, Mr. West, Mr. Tharp, and Mrs.
Clarke Hall are all contributors to the exhibitions of the Club. We may
conclude, I think, that the prize-winners in the Slade School Competitions of the
last ten years are already producing work which confirms the choice made by the
judges in their endeavour to distinguish real from superficial talent.

HUBERT. L. WELLINGTON.

THE PRINCIPLES OF TEACHING DRAWING AT THE SLADE SCHOOL

MY purpose in this essay is to try to give the principles of teaching Drawing at the Slade School. A method of teaching should be capable of rational exposition. It must depend upon first principles. And, be it said in excuse for my own style of exposition, first principles are apt to be cut and dried. I have found the theme a difficult one, and have had neither sufficient leisure nor space for giving it the consideration that is due to it.

I presume that there is little or nothing here which is not to be found in the best treatises upon the function of Drawing and the correct method of teaching it, but I am not conversant with such literature. All that I have written has been evolved entirely from the methods employed at the Slade School. Yet though I feel that I have laboured too circumstantially to prove much that must have been long accepted as true, for the sake of what little unity I can give to the essay I have found it necessary to argue each point with equal care.

––––––––

In sculpture, painting and drawing there are three elements: the spiritual or "literary" element (viz., that which represents the relation between man and man), and those of colour and form. These three elements represent three corresponding emotions in our life of reflection and sensation. A draughts man, like the sculptor and painter, can express, even if only by analogy or symbol, the spiritual emotion. All such expression, however, must be dictated by the draughtsman's own character, so it is not in the power of the drawing master to teach it. But inasmuch as the emotions of the forms and colours of nature are derived from material and visible things, it is reasonable to suppose that upon this common basis there can be constructed a principle of teaching which may be of real assistance to the student. Such a principle

would be evolved solely from the physiological effect which the material forms and visible colours have upon him. Here the teaching of drawing must find its limit. As to whether that which is produced by the student be rich or poor must depend upon his own richness or poverty of feeling and vision.[1]

Since drawing is colourless it seems no unfair assumption to say that it cannot represent or suggest colour. But if proof of this be necessary, let one make the attempt to draw colours by any method whatsoever, and no two people, not in the secret, will agree as to what colours were meant. Again, imagine a many-coloured object or landscape. The draughtsman would have to render the colours by corresponding tones of light and dark. But as he must give the modelling of the original by the same means, *i.e.*, with tones of light and shade, a conflict is set up between his chiaroscuro and his colour scheme. Forms that were salient in the original, owing to their position towards the light are thrown back in the drawing simply because they are dark in colour, and *vice versâ*. This change and interchange of tones must defeat any attempt to render the harmony and appearance of the original as the draughtsman saw and knew it. Some of the best draughtsmen have drawn colour to a limited degree, but never where the effect of the light and shade of their conception was at stake, and the best engravers have found it necessary to reduce their painted originals so far as possible to a scheme of light and shade. But they, and we too, upon the above argument, would maintain that "colour" in drawing is often a disturbing element, and at all events quite disassociated from the chief power and purpose of the art.[2] Therefore, since drawing cannot give a fair or even approximate presentation of the colour of nature, it would seem that nothing was left for it but the representation of form pure and simple.

But at the present time we occasionally hear of getting an "effect" by drawing. What are these effects? Certainly such aspirations in drawing have

[1] It may be possible to develop to a certain degree, on traditional lines, the decorative instinct for pattern, rhythm, balance, etc., without which no composition can be good. But this instinct, essential to all the manifestations of art, thought, and action, is not founded upon a material basis, like colour and form, so it can have no part in a discussion about the teaching of drawing from nature, and of such drawing we are treating.

[2] In black and white illustration, there is a use made of lights and darks. Such work does not, I should think, pretend to suggest colour, and, not being done immediately from nature, it can prescribe its own harmony, or, rather, balance of lights and darks to suit the composition. These arbitrary schemes of "colour" in monochrome (especially in their more extensive application to landscapes with figures) appeal directly to our instinct for pattern, and do not relate to the colour effects of nature as we see and know them: and for the reason given in the foregoing note, it does not come within the province of this essay to discuss them.

been unknown until recently. Call them what you will—sunlight, vibration of light, atmosphere, etc.—the only effects in nature (and presumably therefore in the representation of nature) are those produced by light striking upon form and mass, for instance, mountains, rivers and mists. Independently of form, light and shade would be unperceived, unknown—so if we give light and shade we are necessarily giving form. Hence, the representation of form still remains the one and only power of drawing. If draughtsmen choose to represent with the pencil effects of light and shade upon vaporous rather than substantial forms, theirs is not for that reason a new function of drawing. If the old masters of drawing did not often attempt such subjects it was because they derived more emotion from the more solid appearances of form, or felt instinctively that line and monochrome were little adapted for presenting forms under subtle atmospherical conditions.

To illustrate the singleness of power and purpose of drawing I would differentiate it from singing. Singing has two values: the emotion expressed, and the means of expression, viz., the tone of the voice. It is possible, nay, common, for people to sing beautifully with a poor voice, and it is not always unpleasant to listen to a good voice, though what is expressed may be commonplace. But drawing can give no colour which might compensate for bad draughtsmanship, a line *per se* cannot be beautiful,[1] and it admits no " effects " other than those of light and shade. Drawing, then, has nothing to recommend it except that which it expresses, which is form. And if it do not excel in this, it falls flat.

The draughtsman is thus no less limited in his resources than the sculptor, though his scope may be far greater. In the capacity of workman and not of poet, the draughtsman is like the sculptor in that he is limited to the expression of one emotion, the emotion of form. And like the sculptor, only by a thorough grasp (I use the word only half-metaphorically) of form can he have any emotion to express. A drawing is plastic in graphic form. For this reason what is called a " sculptor's drawing " has no peculiar meaning for us at the Slade, since it is just this " sculptor's drawing " that we try to make, and no other. There *is* no other.[2] Examine Titian's big drawing

[1] Reservation is to be made for beauty of line in conventional and decorative pattern. It is impossible to think that line can be beautiful in drawing that professes to express the forms of nature if it do not show a clear and learned interpretation of those forms.

[2] I think that those who make a distinction between a draughtsman's, a sculptor's, and a painter's drawing would find a difficulty in determining from an unknown drawing whether the author of it was a sculptor, painter, or draughtsman. The difficulty would be greater when the author might be all three of these.

with its amazing presentation of rolling land in sunlight, and of the deer
being 'startled by some people with a toy-spaniel from underneath the shadow
of a tree ; examine this, and the means by which he produced the lively
effect will be found to be the simplest statement in light and shade of his
comprehension of form. By examination also it will be clear that only by
this means could the significant contours of Holbein, or the sensuous revellings
in form of Michel Angelo have ever been.acquired.

There are people whose emotion for the forms of nature are as engrossing
and satisfying as the emotions of others for the colour. We cannot doubt
this if we consider our own sensations when we contemplate a greyhound,
for instance, or fields and mountains, not to mention the human form.
The reason *why* form gives rise to an emotion need not be discussed here.

There are drawings which make us feel that the draughtsman has been
learning at every touch, or if they be not direct from nature they will show
a constant effort to represent observations previously made from nature. To
the eye accustomed to stylised forms in art, and formal style, these drawings
may appear other than beautiful. But they have beauty. So long as the
artist is making discoveries, his work, though it may puzzle or irritate some,
will be eloquent to others who have experienced the emotion of form. Now
the only forms we know are those of nature;[1] therefore, if nature is beautiful
this work of research is the only kind of drawing that *can* be beautiful.
To determine which forms are beautiful in nature, and which are not, is a
matter for the theorist and novelist. The lover of the forms of nature knows
no such distinction. The painter is not judged by his selection of this or
that effect of light, but only by the truth of his representation. Nor, I
think, can the draughtsman logically be judged by the forms he selects, but
by his representation of them.

It often occurs that a draughtsman becomes content after a time with what
he has learnt from nature, perhaps feeling he can learn no more ; he proceeds to
work with better confidence after an arbitrary manner of his own. He con-
fessedly sacrifices the more learned and truthful representation of the forms of

[1] This self-evident fact must be recognised here and elsewhere. An artist cannot invent forms that
will be plausible to those who study nature. Imagined forms (dragons, for instance) are always created
in the first instance with due regard (according to the power of the artist) to natural forms. Later, by
repetition, they may become conventionalised, or meaninglessly exaggerated. When, however, a good
draughtsman takes up the type he will always enlighten it with a show of natural construction and
parts.

nature to the attainment of a "style," which is praised for what is called a sense of line, penmanship, and other peculiarities. Each stylist has his "style," which is peculiar to himself. Their forms do not relate to nature but to the stylist who did them, so that the searching student cannot find in them an explanation of his own difficulties or aspirations. If stylists do not think fit to be over scrupulous in their rendering of the forms of nature, by what feelings or experiences of our own can they be judged or appreciated, since we know of no other forms than those of nature ? And if they should acknowledge that their drawing is not exactly what a sculptor would call a working drawing, and should assert that it is permissible to neglect the purely organic facts of the single parts of reality so long as the entire composition please the eye, then their work is not dependent upon nature for its beauty, but upon decorative principles which have been mentioned above. Being such, it must bear comparison with the best decorative art of the world, notably the Eastern ; and here, moreover, it will be found that there is the finest drawing in our sense of the word, viz., the respectful and learned rendering of the forms of nature. Yet since my essay treats not of drawing but of its teaching, I do not insist further upon this point than to ask the question— Is the student to acquire style from nature, or the work of the stylist ? Are we to get our ideas of life from life itself or from what has been written about it ? Plainly from nature and life. Style, then, cannot be acquired by the student by imitating the habits and mannerisms of stylists.

If the capricious and ignorant representation of nature do not seem to deserve the term style, what is style in drawing ? and how can the student hope to attain to it ? There have been master draughtsmen of every time and country who by their own words, as well as their works, are known to have been infinitely respectful to the form of every detail in nature. Their drawings always recall to our minds reality as we ourselves have seen it, *i.e.*, if we have studied form from nature and not from pictures. The drawing of a hand, for instance, by Hokusai, Rembrandt, or Ingres revives in us our own impressions of the forms and aspects of real hands. In a word, there is manifest in all these drawings, whatever the difference of medium or superficial appearance, an entire dependence upon the forms of nature. Hence it is impossible for us to imagine they were conceived and executed with the conscious effort to obtain some independent and formal "style." The style they plainly have can spring only from this common quality, their truthful and well understood representation of the forms of nature. *Style, then, is the expression of a clear understanding of the raw material*

from which the artist makes his creation. In drawing, the raw material is the forms of nature. Without this clear understanding no style is possible. Now as there is only one way of understanding one thing, there can be therefore only one manner by which it can be rightly expressed. But it does not follow from this that, because the manner of Michel Angelo is different from that of Dürer, one or both show a lack of understanding. The understanding of no two people, by reason of their different temperaments and constitution, lies in exactly the same direction. Nature, being so much raw material, is inexhaustible in the conceptions and moods she gives; hence there are as many manners as there are individuals. No two masters will draw even a finger with the same interpretation of what they understand in it; how much farther must they diverge in the drawing of a whole figure or landscape !¹ The simplest incident in life will be so full of varied import that no two people will give the same account of it, yet each account will be, and also sound, true, so long as the narrator limits himself to telling the truth as he understood it.

Therefore, to attempt to employ the manner of another would be to pre-suppose in yourself a perfect coincidence of temperament (*i.e.*, understanding of things), which, especially if you were not under his immediate influence, would be inconceivable.² Your work would be quickly esteemed unspontaneous and false by those who know nature and the truth of your original. Style, as understanding, cannot be imitated; it is one and the same thing in all the manifestations of art, thought, and action, and whenever there is a manner of expressing things (the forms and colours of nature, or the spiritual and intellectual events of life) which does not show a spontaneous and immediate understanding of them, that manner is artificial and spurious, and by its pretence it is misleading to the student. So

¹ It will be shown later (p. 42, l. 6) how those who draw upon false principles, *i.e.*, with a lack of proper understanding, can, and do, produce almost identical results.

² On the strength of able and beautiful work done by pupils in the manner, apparently, of their master, we might be inclined to admit, that a master can teach another to understand form after his own (the master's) manner of understanding. But I think that it could be always shown that what value there is in the pupil's work is his own contribution, and not what he has got from the master. The fact that a pupil is "influenced" by a master implies not necessarily imitation, but when his work is good it implies that he shares by nature to a greater or lesser extent that master's understanding of form. It sometimes occurs that a man can work in the manner of another so well that it is often difficult at first to distinguish the work of the two men. But this does not connote a perfect coincidence of understanding of the forms of nature. It can be explained by the imitator's having the desire and capacity so to learn the other's mind, so far as it is expressed in his work, that he can draw and compose almost entirely within the limits of the forms given by the other's work. Where he has to draw upon his own imagination or observation, it is there that his own hand can be detected.

long as a work be created within the limits of the understanding, however narrow, and no further, it will have style.[1] To act beyond your understanding is to pose, and such conduct is openly lacking in style to those who know better. Whether this or that manner does show understanding let each man judge according to his own knowledge and personal experience of the events expressed. By this reasoning we can determine what style is, and how alone it can be attained, but owing to the varied interests, and often the perversity of people, style can never be universally recognised.

But there are many so-called principles that profess to teach the student style. There are inculcated into the bewildered student terms such as " the ideal," " classical severity," " selection," " purity of line," " tradition," " the grand style," " good penmanship," " Greek," and so on. These are qualities which are found not in nature but in finished works of Art; they are discovered second-hand, so to speak ; and they who preach them to students do not regard the fact that the artists who were first in the field with such qualities, however gradually they were developed, could not have had before them any examples or teaching of this kind. For instance, there are some who recommend the student to assume an archaic or primitive simplicity, etc. They little consider that archaic and primitive art was without the teaching of a foregoing advanced art and critical formulæ, and that therefore whatever qualities we admire in it must have been drawn from, and developed solely from, the observation of nature. So to teach the inquisitive and ingenuous observation and understanding of nature would be the only principle by which the student might be brought to acquire archaic qualities. Moreover, it must be borne in mind that the student, however much he may be persuaded of the importance of æsthetic and critical notions (the ideal, the essential, etc.), when he sits face to face with nature cannot apply them if he would, that is, if he desires to make use of his model, and cares for it for that moment more than for works of art.

What alone will be of use to the student is to be told what it is in nature itself that gave rise to the greater qualities in works of art, so that he himself may search for them in nature, and, having found them, represent them. And all æsthetic and critical principles are, as principles of teaching, superficial and inapplicable, if they be not based upon, and have no regard for, the physiological

[1] A child's drawing has style, but not the work of a sophisticated and incapable adult, be he called artist or amateur.

cause that produced the above qualities, nor for the physiological effect the forms of nature must have upon the student.

It has been so far my effort to show that *drawing can represent only the emotion of the forms of nature, and that only by a clear understanding of them can the draughtsman hope to represent those emotions. It is therefore important to explain of what sort that understanding must be.*

When we look at an object we know two things about it : its colour and its form (by form, I mean not only its length and breadth : its silhouette, but also its depth, its relief). Its colour is known immediately by the eye. But do we know its depth immediately or only mediately by the same sense ? By the colour we discern the silhouette or pattern of the form, its length and breadth, marked off from objects of different colours, but certainly not its depth, since it would be possible by proper manipulation of the lighting to give to a coloured object no appearance of depth at all. But we see also light and shade which give us at once a correct idea of the object's corporeity.[1] But we do not have this idea of corporeity from the eyes alone, *i.e.*, from the mere perceiving of the light and shade : our knowledge of its corporeity is the result of our having from infancy unconsciously observed the light and shade on, and peculiar to, every form we have touched or traversed, and so, by association, we were early enabled to have ideas of the forms of things by their various modifications of light and shade without having to touch or traverse them. These ideas I shall call the ideas of touch.[2] To illustrate

[1] I shall use this word to mean an impression of extension, roundness, relief. I avoid using the trine dimension, since, as cannot be too clearly recognised, our apperception of the forms of nature is in no way dependent upon the recognition of their abstract geometrical dimensions, with which dimensions, therefore, drawing and the teaching of drawing can have nothing to do.

[2] The above proposition of the twofold impression of form received by sight has been the direct, and, I should think, the inevitable outcome of searching for a fundamental principle which would apply consistently to the method of teaching drawing at the Slade School. I have since had my attention called to Bishop Berkeley's " New Sense of Vision " (1709), wherein he was brought to discover the same fact for the purpose of exposing some of the doctrines of geometry. I have made this statement because Bishop Berkeley's theory, in confirming my own, which has been evolved quite independently, must go towards confirming the principles of teaching drawing here stated.

this imagine an orange and a disc, of the same diameter, covered neatly with orange peel put before me. By having constantly touched spherical forms, and as often observed upon them a peculiar disposition of light and shade, and *vice versâ*, I judge the one having that disposition of light and shade to be a sphere, and then from its colour I infer that it is an orange.

Thus we see light and shade (whenever we are conscious of seeing at all), not as a pattern in itself, but merely as a guide and indication to the form which we unconsciously traverse or touch in our minds. If some may still suppose that we can know form intuitively by sight, without having first learnt it by touch or locomotion, they must remember that the elements of form and distance we learnt in childhood by touch and locomotion are once and for all sufficient for practical purposes, and that now we see and understand an infinite number of forms for every one we touch. The purely visual sense, which gives us ideas of the silhouette, is only the *means* by which our ideas of touch are stimulated, *and it is immediately and solely through the ideas of touch that we can have any ideas of form.*[1]

It follows that any emotion we might have from contemplating a form in nature or in art must come through the ideas of touch (whether consciously or unconsciously it does not matter), for without touch we cannot know, nor could we ever have known, anything about the form of things. It has been shown that drawing expresses the emotion of form, and in this alone it is fully justified as art. Now since the draughtsman cannot, if he would, reproduce form in its own material, but represents it on paper and with pencil, that which he represents is not the form itself, nor could it pretend to be an illusion of it. The line and shading made by the draughtsman are no more an imitation of the object represented than are words an imitation of the thoughts or events they express. *The draughtsman can give only his ideas of the form These ideas, if they are to represent form as we know and appreciate it, must be ideas of touch.*[2]

[1] Some may maintain that it is through our binocular vision that we know at sight form in its three dimensions. If that were so it would be logical to suppose that we, if we closed one eye, or a man born with one eye, would have no conception at all of the roundness of a form by seeing it.

[2] That drawing must express the third dimension must be the commonplace of all drawing schools. For whatever virtue drawing has had, or ever will have, is due to its conformity with this principle. However, we hear so frequently of the virtue and importance of an absolute line or contour, abstracted, it would seem, from its subservience to the expression of corporeous form, that it might be doubted if the paramount position held by the ideas of touch in our apperception of form has been so fully grasped as to make it the only principle by which corporeous drawing can be profitably *taught*. The ideas of touch know no contour.

If a draughtsman or a beginner employs only his ideas of sight, *i.e.*, if he merely copies or imitates, measures and plumbs,[1] with however much skill, the silhouette of the object (a model, for instance), and the lights and shades also as so many patterns or silhouettes, and its main divisions (he might erroneously call it the construction) as so many geometrical figures, just as if the model were a painted target, and never consults his ideas of touch, how can he say he is representing the corporeity of form as he knows it and appreciates it? How can he expect by this procedure to give others ideas of touch when he never had them himself? He cannot. This man's *compositions* may turn out to be (or may have been before he studied nature) decorative in the highest sense by reason of their pattern and rhythm, and thus appeal to a very strong instinct. But as his drawing does not give us ideas and evoke in us the emotions of the forms of nature, he has not done that which he presumably set out to do, viz., represent nature. . . . Even as we once learnt to recognise form through the ideas of touch, so must the draughtsman, if he sits before nature, learn to express ideas of touch, and those only on paper; in other words, he must learn to draw what he feels and not what he sees.

The above two dimensional method we call at the Slade School "Copying." A new student almost invariably begins in this manner. As an illustration of the method and its inevitable results, I would construct a parallel from music. If a man born deaf were taught to read music on the piano, he would never be able to give an individual interpretation or expression to a piece, because he could have no idea of sounds and tones and their values. His playing would be, to those who are musical, utterly insignificant. He is playing by sight and not by sound.

[1] Measuring and plumbing are not encouraged at the Slade. If students can learn to render the proportions and attitude of the model by the eye alone, it will surely prove an ultimate saving of their extra physical labour in drawing, if nothing else. But if the forms of nature were two dimensional, the system of measuring, which must necessarily be two dimensional, would be useful and legitimate. But all bodies have the third dimension, depth or relief, which must be equally as important as the length and breadth. This, of course, can be measured only by the visual-tactile sense, so it would seem strange not to train the student to use his purely visive sense for telling also the other two dimensions.

When we see any three dimensional form (the human back, for instance), we do not apprehend it spontaneously as having so much of length, so much of breadth, so much of depth, but we feel all three dimensions together in such a manner that the form appears to us as one corporeous mass, which, when clearly conceived, can be readily modelled with no thought of its mere geometrical proportions. And if this be true for the human back it must be true for the whole body also, for landscape, and all things in nature. The ideas of touch know no dimensions. We do not instinctively see and feel forms by a series of abstract measurements: therefore, if the student is to draw what he feels, it would seem a little illogical that he should be taught to spend his time in giving, as a special act, his ideas of the third dimension to a drawing that has been mechanically planned out first in the flat.

If it were possible to instruct him where to give "expression," the interpretation would not be his own but his teacher's. This man could never be a musician, nor could his almost equal, the man with "no ear." For the same reason the man who draws by sight and abstract measurements, and not instinctively and wholly by touch, is drawing like a parrot, and can never be a draughtsman.

In order further to explain and confirm my statements I should like to draw a few more conclusions as to the wrongness of the unprincipled method of drawing "by sight." (i) How is such a drawing to be judged good or bad? Surely only by its exactitude. But not according to the exactitude of the drawings of Millet or the Chinese masters, for these could not properly be called exact. Then it is the exactitude of the photograph. But if photographic exactness is the aim, how can the drawings of those masters be good? (ii) If the student "copies" the model how does he know when to stop, for to reproduce exactly the subtle contour and darks and lights (as well as the colour, for this must be the logical accompaniment of the two dimensional methods) of nature would be an infinite affair. (iii) Yet let it be granted that an accurate copy of the model be possible, then this *tour de force* is no better than a photograph, that is to say, it has merely reduplicated the aspect of the model, minus the colour, and the spectator is no better off than he was before he saw the drawing. It has told him nothing. Being conceived with no ideas of tangible form, it gives him none. (iv) But some would affirm that if drawing is the expression of our emotions of form, it is certain that much emotion.is felt by those who merely copy. I would reply that this is not an emotion of form, but an elated mood arising from the copier's satisfaction in possessing such a perfect interaction between retina and hand. (v) In this method what is there to teach? If the student requires to know where he is incorrect, surely a tracing on glass would suffice.

With such questions and answers must the student with this method be constantly puzzled. I am sure it must often have occurred to the industrious copier that what he is doing with infinite pains could be done better and more cheaply by a photographer.

Since the works of painting, sculpture, and drawing have to all appearance more material resemblance to what they represent than music, architecture, and design (which represent abstract ideas of tone, mass, and pattern), they have been separated from the other arts under the title of "imitative." But

G

such a distinction can be shown by the above facts not to exist; the "imitative" arts none the less represent ideas ; and the ideas of touch which drawing has to represent are as immaterial and personal as those of tone, mass, and pattern. It is the possession of ideas of touch that makes the draughtsman, just as it is the possession of ideas of sound that makes the musician. We all have very nearly the same power of vision; hence the similarity between one copier's work and another's. But the individuality shown in the works of great draughtsmen is due to their very different ideas of touch. Words will not, of course, express the subtler differences between one draughtsman's individual manner and another's. But such phrases as "delicate touch," "rough handling," "nervous feeling," etc., as applied to drawings, must be understood in their literal sense. They tell us the manner in which the artist visually touches or handles form. Both the detail as well as the entire character (technic, if you will) of a master's work is determined by his temperament: that is, his peculiar understanding of the forms of nature.

I will add two concrete instances of practice which should illustrate, though roughly and incompletely, the above principle. It is plain that anyone could shade a ball, even from memory, so as to give it approximately a spherical appearance. This is only because he is perfectly acquainted with its cor-poreous form, a very simple one. Moreover, he will not have given the shading as a special act of finish, but instinctively as the only means of expressing his idea of that form. If that shading express the form as we know it, the end has been achieved. There can be no such thing as good or bad shading, modelling, penmanship (call it what you will), *per se*, or as an end in itself. If the shading looks ugly it is because the form is carelessly or not well conceived and expressed, and *vice versâ*. At the Slade we are taught to "look after the forms and the shading will look after itself." It follows from this simple illustration that any single form (of the human body, for instance), when perfectly understood in the sense of its corporeity, could be expressed perfectly by a poor draughtsman, who would become by that act alone a perfect draughtsman. But it requires as much practice and deliberate obser-vation to acquire ideas of touch with a view to expressing them, as it did in childhood before we could know form for what it is. Drawing is an addi-tional faculty dependent upon that knowledge of form, but infinitely more definite than that which we require for everyday non-artistic use.

So much for shading. What is contour ? Suppose a well-raised rounded

projection on the ball which is so placed that part of the projection is seen beyond the contour of the ball. Here, again, not even a very poor draughtsman would draw the contour of ball and projection by one continuous line ; but in order to get the all-significant angles at which the projection breaks the contour of the ball he would instinctively stop the main contour at these points and separately draw the projection from where it starts on the inside.[1] So must the student proceed in the drawing of the contours of every form in order to give the idea of a content within the silhouette. By this method the contour or silhouette is determined entirely by the draughtsman's consciousness of the inner modelling, which inner modelling is known only by the ideas of touch.[2] Moreover, contour being *in nature* an ideal line between one form and others, it is illogical to treat it and criticise it in *a drawing* as an actual and specific thing, apart from the forms that make it. *Contour, then, has no beauty or value in itself any more than has shading : they are both of them beautiful and have value only in so far as they are determined by, and pregnant with, ideas of touch*, i.e., *in so far as they express the corporeity of form.*[3]

Solely upon this principle, then, and by such methods can the draughtsman give an appreciable representation of corporeity without which drawing cannot give us an emotion of form.[4]

But it is yet to be shown that there is only one principle upon which

[1] It is needless to observe that after long practice with this method, the entire contour of any complicated form can be drawn significantly with one uniform line.

[2] That the telling contours of figures on Greek vases were originally found by this method is often witnessed by the faint lines done with a style or with pale brown ink within the silhouette. In the disreputable repetitions of the same figures by inferior vase painters the interior lines are either misunderstood or not employed. They neither observed them nor did they know the purpose they had served.

[3] Hence it is clear that to draw the outline of a face in profile demands less feeling for corporeity than would be demanded for the contour of a human figure in violent foreshortening, for in the profile the contour is maintained by the nature of its structure more or less uniformly, and in the other it is determined everywhere by projections from the inside of the silhouette.

[4] What we admire in drawing of primitive art cannot in all cases be attributed to the strict accordance with these principles, but rather to the sincerity and comparatively great learning shown in its efforts to realise some such principles. Indeed, it is only the partial accordance with the principles stated here that distinguishes primitive art from that of a more enlightened period [*cp.* E. Loewy, "The Rendering of Nature in Early Greek Art" (in preparation), who gives a remarkable statement and explanation of the forms of primitive art]. Primitive sincerity and energy of observation we may emulate, but may we any longer slavishly imitate their forms ?

the draughtsman can make an appreciable representation of an entire object (or series of forms such as a landscape).

When we see an object we apprehend it as a whole at a glance. In a moment we derive a greater or lesser emotion from its general character. Later observations of its details will not add to our first conception of its character, but only make us familiar with one part or another of it which may be conspicuous for some comparative value. Indeed, familiarity with an object or scene diminishes the clearness of our first conception of it, and brings nothing into its place. Whatever we feel about the object, and what makes it different from all objects of like or unlike nature, is its general character, and this we comprehend at first sight. As soon as a boxer, for instance, takes his position, we have an impression of his general character. If we notice, a second later, some definite peculiarity about his bearing (the carriage of his head or hands, for instance), we cannot say that it was this that determined his character, since another might imitate these peculiarities and yet remain clearly a different man.

The character of an object, then, is not determined by one or several peculiar properties, but by the entire complex of its constituent parts, viz., variously proportioned, three dimensional forms which we call its construction. The construction gives its corporeity or three dimensional quantity, its action, attitude, relative proportions, directions, planes in space, etc. Such qualities as these, then, constitute the character of an object, and give us whatever emotions we may have from it. The character of a single form or congeries of forms is given by its corporeous construction. What we like in a landscape is its peculiar disposition in length, breadth, and depth. A single promontory, for instance, does not constitute the character of the scene. A big nose is not the character of a man's face, though it may be a characteristic of it.[1] Whatever attracts us in the human body is not first and foremost a mouth or a leg, however rapidly we may be drawn off to observe such details for themselves ; but the attitude, action, and proportions of the whole, its construction.

So the construction of any object or scene in nature, indescribable in words, and vague enough, maybe, in our minds if we try to recollect it,

[1] When we speak of the character of the face, we ordinarily mean some moral quality, and not constructional. But it amounts to the same thing, because when we see a certain type or construction of face we can judge of its possessor's moral character only by comparing and associating it with the faces of others whose moral character we know from personal experience. The only character that an artist does, and by nature of his resources *can*, attempt to represent is that of form, viz., construction.

is yet the first thing that strikes us and the first and only cause of any appreciation that we might have of it.

Therefore, if the draughtsman's work is to adequately represent what he appreciates, he must not occupy himself with giving numerous striking properties, but he must give a single conception of the object's character, viz., its construction.

The more sensitive the draughtsman be to the value of the constituent parts, not as units, but strictly in their bearing upon the object's construction, by so much truer is his conception, for it approaches nearer a complete unity of all the parts.[1]

It is because the senses and mind are incapable of receiving two impressions at the same time that unity of conception is required of all art and reasoning, for these profess to represent impressions of the senses or mind. Writing poetry, or composing the subject in a picture, is the selecting from a chaos of notions and ideas those only that are of service to the one original conception of an event in human life. Painting is the bringing of many colours, each having its own individual value, into one harmony or conception as determined by a particular character in the colour effect of nature. And so the musician, architect, and designer build up their original conceptions, their respective theme, mass, or pattern, with only such material that will serve it. In all cases the value of a work is commensurate with the original conception and not with the detail, however elaborate. So, too, *a drawing of a human figure must express one conception, viz., the conception of its character or construction, which must be as single in conception and expression as a drawing of a square box.*

Before he can touch the paper to any purpose, the draughtsman must have a conception of the corporeous whole. But how few of us can picture, in our minds or on paper, such a comprehensive conception of the construction of any object! It is not until we try to express on paper our conception of the construction of an object that we know how vaguely we have conceived it. Form to the unschooled is so manifold and bewildering that I doubt if the majority of people (adults no less than children) have any conception of the

[1] The "skilful" or the virtuose draughtsman or painter in a surprising manner gives his conception of the whole, but it is determined by the grosser constructional elements of the object, and not by the entire complex of elements, to the more delicate of which he is by nature insensitive. Hence the result is half characteristic, common. The caricaturist, on the contrary, can form a very subtle conception of the construction of the model; and, to the end that this may be the more emphasised, *i.e.*, exaggerated, he, whether by intention or incapacity, sacrifices in his work all detail that, not being indispensable, might detract from the clear expression of it. By such sensitiveness of observation and conception is his work wholly justified. There are caricaturists also who are virtuose in the sense given above, *i.e.*, common.

forms and colours of nature other than what they have derived from pictures and drawings; just as the abstract ideas expressed by most people do not, I should think, originate from their own mental apparatuses, but come from a stock, now common property, the inventions of men of original conception.

Therefore, when a student starts to draw an object (a model, for instance), he must not think, because the form is before him ready made, that he need not be at pains first to form a unified conception of its corporeous construction (*i.e.*, its attitude, action, and proportions), and that all there is to be done is to draw it form by form, as though he were " making an inventory of it," as we say at the Slade, and that after long practice he will be a master. On the contrary, the model itself is *not* a unity of form. It is, as we have called it, raw material. It gives the beginner little or no conception at all of its general character that he can express on paper. So that if, without a preconceived idea of its construction, he set himself to draw the model form by form, with the varying impressions he must receive from each, how could he expect the result to express one idea of the entire form, *i.e.*, its character? Could the painter hope to carry out his conception of a colour effect of nature if he merely matched the individual values of the colours without keeping his eye on the whole? Would it be a novel if the author wrote down every idea as it came into his head without clearly preconceiving his plot and characters? Would it be a drama if a man brought on to the stage, if possible, people who, with infinite time, would enact a romance with all the irrevelant and accidental events as it happened in actual life? The answer is always no. For in each case the majority of people would see no meaning in it at all, and the rest would have to form each his own conception of the matter. In neither case has there been created a unity of conception out of the variety of life and nature. The student in question, having no spontaneous and definite conception of the object's character or construction, has attempted by diligence of imitation to exhaust the possibilities contained in it, in the vain hope that in the result there will be something for everyone. Moreover, the fact that his drawing when finished does not represent his *own* conception of the model, a very limited one, does not concern him. Zola said that art is " nature seen through a temperament." Have we not here nature seen through a looking-glass, and that darkly? Hence a highly finished drawing by a student in his first, or even second or third year, would contain much that was forced, or mechanically introduced. If a master of drawing rarely, if ever, achieved

success with an elaborately detailed drawing, can a student be expected to? Who can say for certain that drawing, even in the hands of a master, admits elaborate finish as it is ordinarily understood? In a word, if it be only by the corporeous construction of an entire form that we know and appreciate it, is it not by presenting this in its complete isolation that the slightest sketch of a master is of high value, whilst the elaborately finished work of the student without a conception is of no value at all? [1]

Upon this principle it might be asked, What is the beginner to do, since he must begin at the end of art, so to speak, viz., with a unified conception of the whole? Surely he must be as badly equipped with what to express as the child would be, for the same reason, for writing philosophy? And so he is. He can be taught to draw only by the same method as we learn to talk or reason, viz., Rem tene, verba sequentur. In drawing, the matter is a corporeous unity; hold this, and the line and shading will follow without your or your critic's being conscious of it; they will follow only in correspondence with the fulness of your conception.

It is not my purpose to give an account of the methods by which the development of this indispensable conception can be encouraged and helped. Suffice it to say that we get no teaching and assistance at the Slade School but what would tend to its development.

JOHN FOTHERGILL.

[1] It might be maintained that to thoroughly drill the student in the working out of details is the only method by which he can ultimately acquire breadth and freedom. But how is it to be supposed that freedom and breadth will spring untaught, unsought for, from an ever increasing love and knowledge of detail? Breadth and freedom must be taught first and the detail will follow easily into its own place. Even as you can train muscle on to a hound only in proportion to the size of its bone, so will the putting in of the detail be of use and instructive only in proportion to the solidity of the general construction with which the student starts his drawing.

DRAWINGS
DONE AT THE SLADE SCHOOL

DRAWINGS AND PICTURES

BY

SEVERAL PAST AND PRESENT STUDENTS

OF THE

SLADE SCHOOL

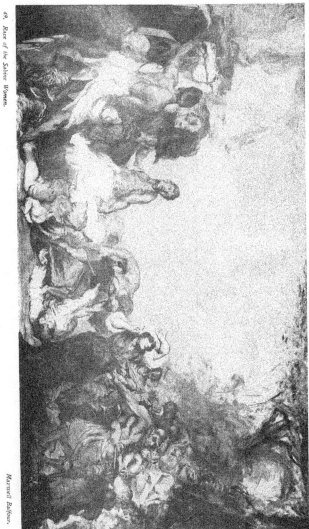

49. *Rape of the Sabine Women.*

Maxwell Balfour.

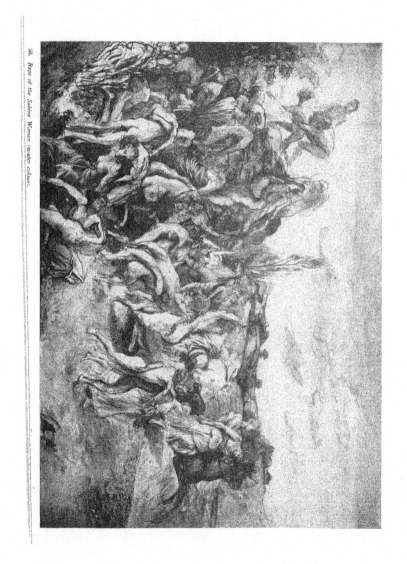

50. *Rape of the Sabine Women* (water colour).

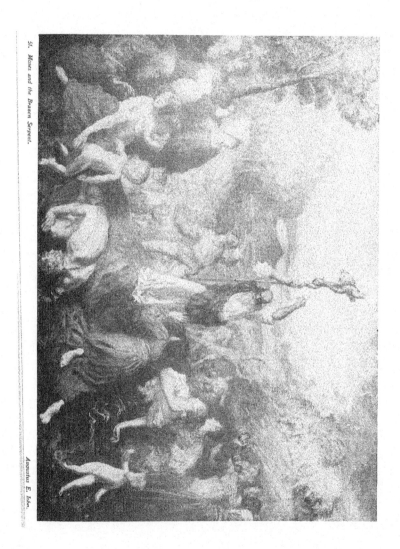

51. *Moses and the Brasen Serpent.* *Augustus E. John.*

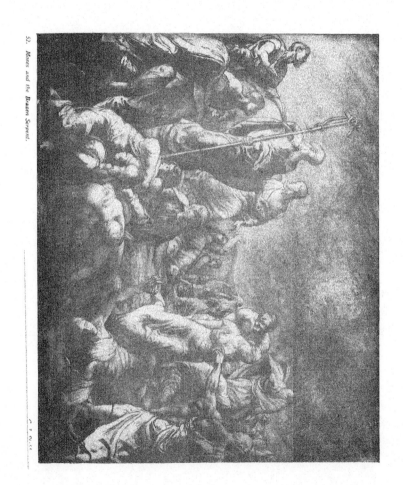

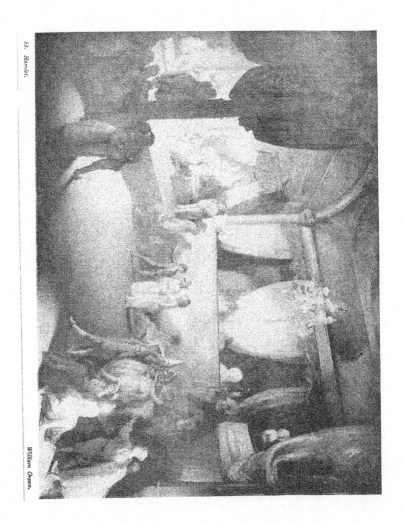

53. *Hamlet.* *William Orpen.*

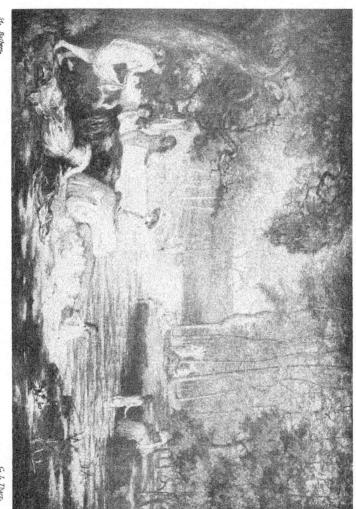

54. Bathers.

C. J. Tharp.

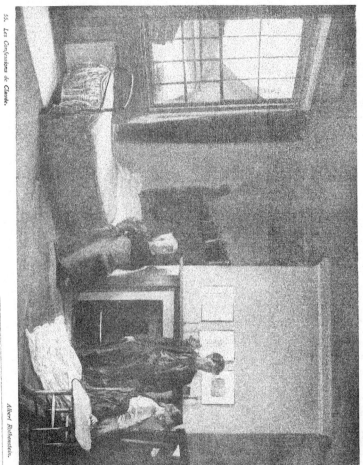

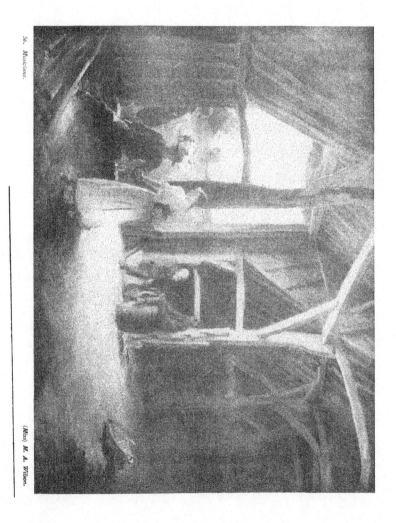

(Miss) M. A. Wilson.

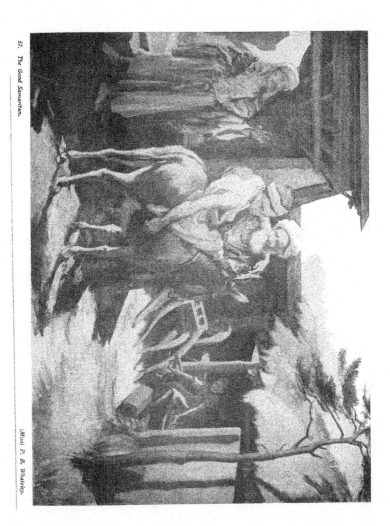

57. The Good Samaritan.

(Miss) P. B. Whateley.

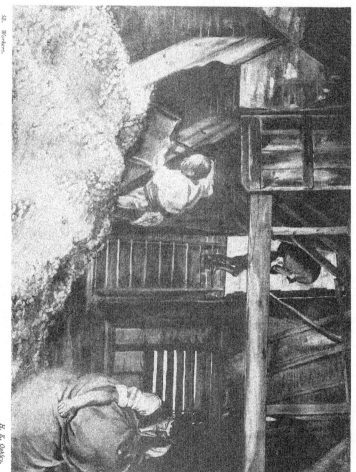

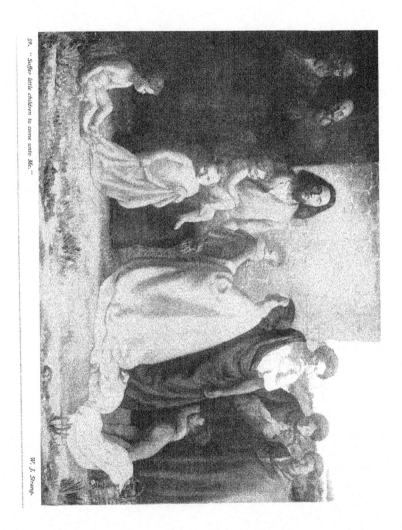

59.　"Suffer little children to come unto Me."

W. J. Strang.

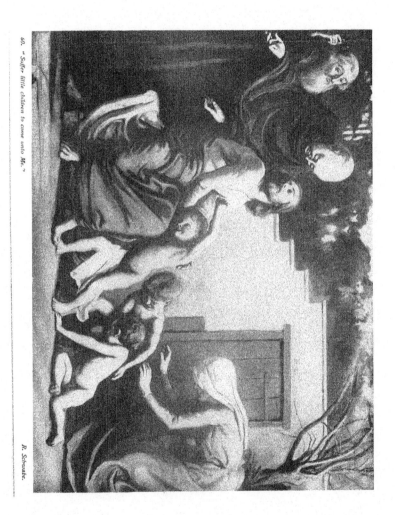

60. " Suffer little children to come unto Me. "

R. Schwabe.

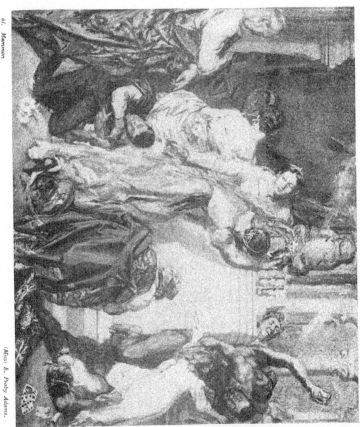

61. *Mammon* *(Miss) E. Proby Adams.*

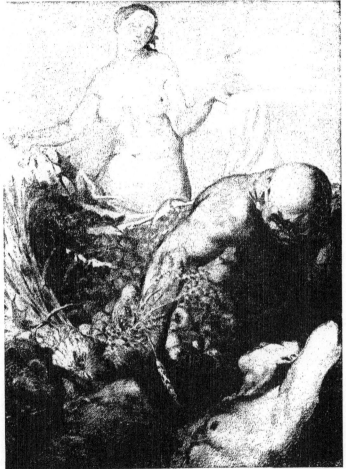

62. *Mammon.* *Edward Morris.*

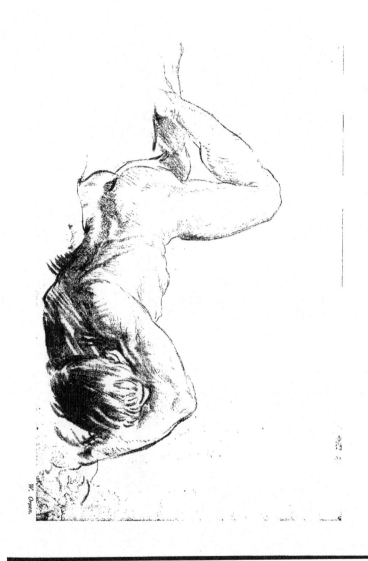

W. Orpen.

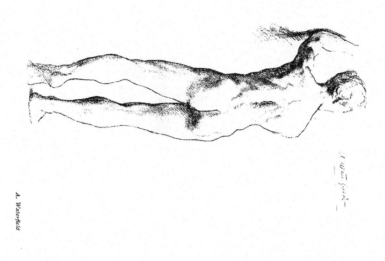

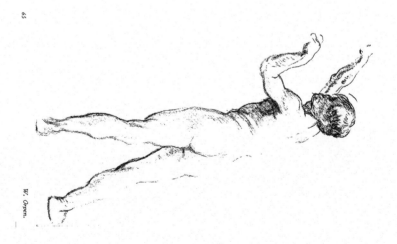

A. Waterfield

65

W. Orpen.

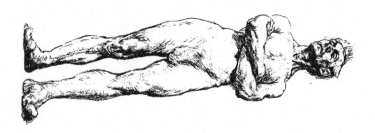

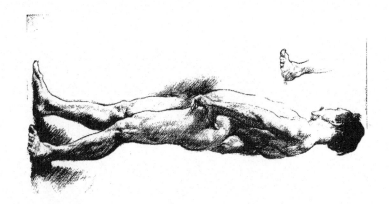

J. H. S. Shepherd.

W. Rankin.

D. MacLaren.

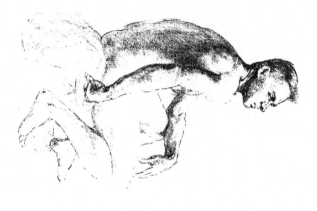

C. R. Webb

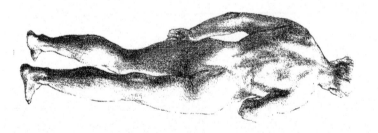

D. Lees

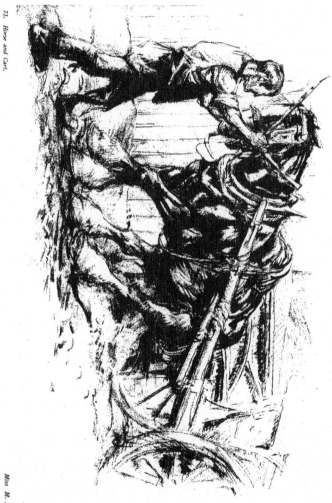

73. *Horse and Cart.*

Miss M. Fisher.

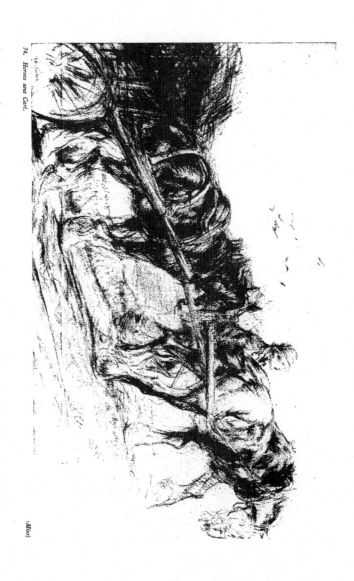

74. *Horses and Cart.*

(Miss)

75. *Ship in a* **Yard**

D. James.

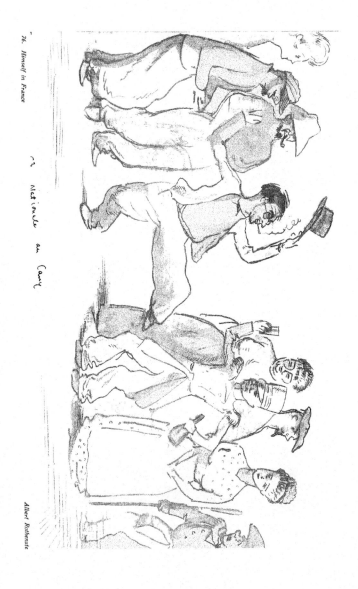

76. Himself in France

Net incle en Cony

Albert Rothenstie

J. F. *holding the Gridiron up to the* fire

La Fuerza civil

78. *Himself.*

Bert Rothenstein.